IMAGES
of America

SAUSALITO

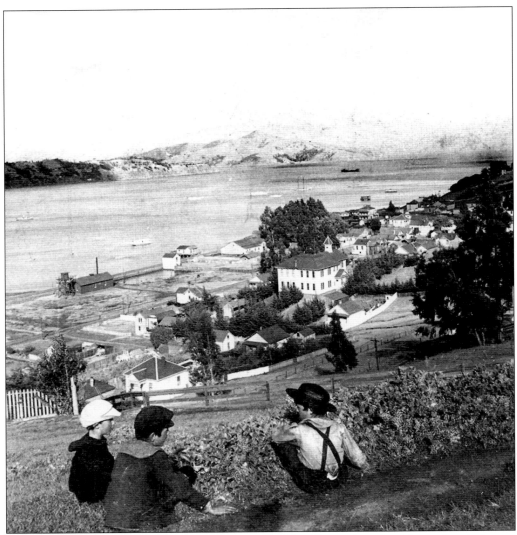

Against the panorama of north Sausalito, known as New Town, three local boys plan their next adventure. In the distance, Angel Island is at the center, and to the left is Belvedere Island. Perhaps the boys are talking about their school, which occupies the middle of the landscape, or about boating or chasing a few cows. Anything feels possible in this nostalgic 1901 photograph documenting the once pastoral setting of the town.

ON THE COVER: This early-20th-century photograph of Old Town Sausalito captures the special juxtaposition of the protected harbor and the intimate village nestled against the hills. More than a century later, Sausalito retains this unique feeling of being directly related to its topography.

IMAGES
of America

SAUSALITO

Sausalito Historical Society

Copyright © 2005 by Sausalito Historical Society
ISBN 0-7385-3036-0

Published by Arcadia Publishing
Charleston SC, Chicago IL, Portsmouth NH, San Francisco CA

Printed in Great Britain

Library of Congress Catalog Card Number: 2005929111

For all general information contact Arcadia Publishing at:
Telephone 843-853-2070
Fax 843-853-0044
E-mail sales@arcadiapublishing.com
For customer service and orders:
Toll-Free 1-888-313-2665

Visit us on the internet at http://www.arcadiapublishing.com

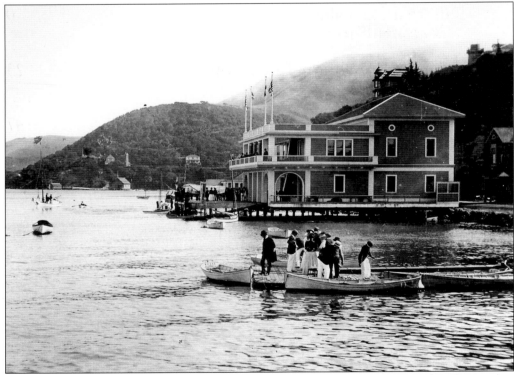

The second San Francisco Yacht Club to occupy the Sausalito waterfront replaced an earlier clubhouse destroyed by fire the year before. It opened with a gala celebration on April 23, 1898, and during its 29 years on Water Street became a locus for the social activities of the Bay Area yachting community. Today the structure remains at the same location, now the home of Horizons restaurant. (Courtesy California Historical Society.)

CONTENTS

ACKNOWLEDGMENTS

The Sausalito Historical Society wishes to recognize all the people who have individually and collectively donated hundreds of volunteer hours to the creation of this book. In addition to our accomplished authors, we wish to thank Margaret Badger, who brought this project to fruition with her superb organizational skills as project coordinator and layout editor; Doris Berdahl, who as copy editor contributed a lifetime of expertise to improving, polishing, and finishing the text; Phil Frank, who throughout the work generously provided historical guidance and design input; Vicki Nichols, who supplied the ongoing continuity and everyday attention to detail essential to the success of a major research project; Wood Lockhart and Kenn Roberts, who made themselves strategically useful with research and technical support, respectively; and D. J. Puffert, president of the board, who brought the idea to the society and unfailingly supported it.

We wish to thank the Bancroft Library, California Historical Society, Northwestern Pacific Railroad Historical Society, San Francisco Maritime Museum, and Sausalito Woman's Club for making their collections available for our use. Finally we are grateful to former Marin County supervisor Annette Rose, whose office granted funds to underwrite the project.

Sausalito is a magical place with a rich history. This book represents a labor of love for all who have been involved with it. It is to the town itself and to its citizens we dedicate our efforts.

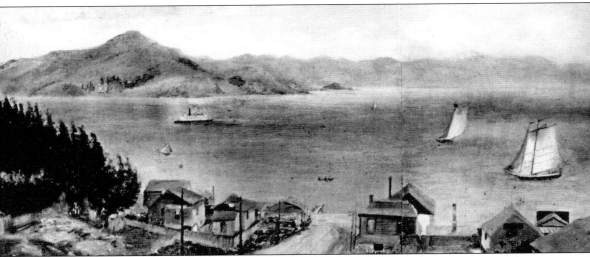

In this lovely painting, an unknown artist has affectionately rendered the San Francisco Bay panorama as seen from the hills above Old Town around 1890. At left, on Angel Island, are two U.S military installations, Camp Reynolds and the West Garrison. In the middle distance lie

INTRODUCTION

Sausalito is like a stage where one production has followed another for hundreds, if not thousands, of years. Whatever the theme or plot, Sausalito, with its characteristic flair, has provided a setting to match the action.

For between three and five millennia, the backdrop it provided for a cluster of Native American (Coastal Miwok) villages remained fairly constant. Its tranquil surface varied little over time. But with the successive arrival in Northern California of the Spanish, Mexicans, and Euro-Americans, the stage was set for dramatic change.

Are you ooking for a new twist on the traditional Western? Sausalito's story as a Mexican land grant in the early 1800s arguably equals the best Broadway musical, replete with *vaqueros*, dons, extravagant fiestas, and, ultimately, the downfall of its colorful leading man. Rancho del Sausalito even had a role in the Bear Flag Rebellion of 1846.

Later with the advent of ferry service to and from San Francisco, Sausalito became the setting for a burgeoning Victorian village—a place of summer houses and hillside estates, populated by wealthy San Franciscans and members of the local British colony. A fleet of British-owned, square-rigged grain ships filled the bay below. But Sausalito, by its very nature, invited diversity.

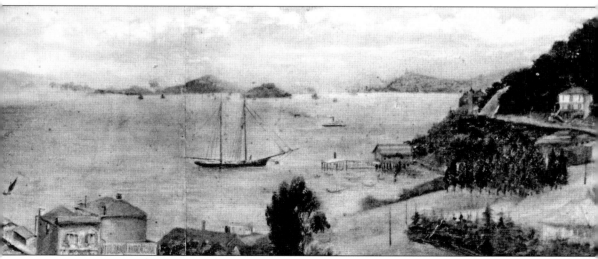

the East Bay hills. In the foreground, modest homes and hotels line the Sausalito waterfront. On the water, steamboats and yachts enliven the bay, while San Francisco is subtly suggested on the distant right. (Courtesy California Historical Society.)

So what other roles were needed to complete the production? Portuguese boat builders, Italian fishermen, Chinese shopkeepers, rail yard workers, ferry crewmen, and dairy ranchers all took their turn on this stage.

The plot changed with the arrival of the first rail line from the north. Sausalito became a transit hub, the connecting link between most Northern California trains and ferries and San Francisco—and the setting for a rousing waterfront story, with all its attendant sound effects. Thundering locomotives, swathed in steam, shaking the earth on their approach; hulking ferryboats with clamoring bells heralding their arrivals and departures; electric trains with their shrill whistles, calling residents, workers, commuters, and travelers to the bustling scene on the town's doorstep.

You want a play about Prohibition? Sausalito looked the part in the 1920s, and got the role. Out-of-town rumrunners, local police, basement speakeasies, backyard stills, federal Prohibition officers—all were players.

The spanning of the Golden Gate was the next drama to be staged. Not only did Sausalito become the northern anchorage for this 1930s production, it provided many of the workers who built it.

Or would you prefer a World War II drama? No problem. Switch costumes and Sausalito is a shipbuilding town, with six shipways operating 24 hours a day. A cast of 20,000 filled this stage, building and launching 93 ships and filling the little town with humanity, excitement, and overcrowded housing.

As abruptly as it began, the war effort ended, and the shipyard flats were cleared for the next production—a 1950s art film featuring painters, sculptors, dancers, writers, musicians, mask makers, bohemians, hippies, and houseboaters. Great character actors dominated the boards during this run—Sterling Hayden, Sally Stanford, Alan Watts, Shel Silverstein, and countless others.

Today the theater has undergone some remodeling, and the scene behind the proscenium arch has become the backdrop for a modern travelogue. The curtain rises on Victorian homes dotting the lower hillsides, sidling up to modern redwood and glass creations clinging precariously to the ridgelines. The stage reveals a historic downtown: yacht harbors thick with white masts, restaurants and hotels built out over the water, unique shops, original art galleries, and grand promenades with San Francisco views. Projected overhead are images of a world-renowned art festival, jazz concerts by the bay, chili cook-offs in the park, folksy Fourth of July parades along Caledonia Street, elegant garden tours in the Banana Belt. In short, all is ready for Sausalito's latest opening night. So let the play begin.

One
Rancho del Sausalito

by Margaret Badger

From the South Soleta journal of W. H. Meyers.

During the 18th and 19th centuries, a succession of outside forces swept over the small bayfront settlement that would become Sausalito, each transforming it in significant ways. In 1775, the tranquil way of life of its first inhabitants, the native Coastal Miwok Indians, was disturbed by the arrival of the Spanish ship *San Carlos*, carrying the first European explorers to enter what is now called San Francisco Bay from the sea. Noting the willow trees along the shore north of the inlet, the Spaniards called what they saw *saucito*—little willows. When Mexico won independence from Spain in 1822, sovereignty over Sausalito and all of California fell to the victor. In 1846, during the Bear Flag Revolt, Mexico's title was symbolically usurped by renegade Californians, then taken away entirely in 1848 after the Mexican-American War. By 1850, the American flag flew over California.

These major historical events provided a backdrop for Sausalito's more intimate story, a tale of strong, independent, often colorful individuals pursuing their diverse visions for this strategically located anchorage just north of the Golden Gate. During the 1820s and 1830s, Sausalito's

9

earliest non-native settlers—John Thomas Reed, a jovial Irishman, and William Richardson, an ambitious English seaman who jumped ship at the Presidio in Yerba Buena (now San Francisco) in 1822—aspired to win a land grant in the vast, sparsely populated region beyond the gate. Although Reed built the first shanty in Sausalito's Shelter Cove in 1828 (and later gained his own land grant farther north), he was not then a Mexican citizen and was thus disqualified. Richardson, on the other hand, had wooed and won the daughter of the commandant of the Presidio in 1825, converted to Catholicism, and taken Mexican citizenship.

In 1838, Richardson, by then captain of the Port of San Francisco, was awarded 19,571 acres of what is now southern and western Marin County. Three years later he moved with his wife and children from Yerba Buena to the southernmost portion of his new holdings, which he called Rancho del Sausalito. There he built his first adobe near present-day Caledonia Street. With the help of the indigenous Indians who labored for him, he sold fresh water from Sausalito's underground springs to Pacific-bound whalers anchored off Shelter Cove (then called Whaler's Cove), harvested timber, and raised grain and cattle, from which he produced hides and tallow. He developed his own portage service to distribute his products and, as captain of the port, collected fees from vessels entering the bay, almost all of which he personally piloted through the complex bars, currents, and tides of the Golden Gate. In essence, he and his family lived both the life of Yankee entrepreneurs and Mexican grandees.

But the forces of history were conspiring against him. Before the gold rush, California experienced little growth, remaining an idyllic, pastoral setting for grant holders like Richardson and landed Californios (born in California of Spanish-Mexican heritage), but not producing significant wealth. As the gold miners bypassed Sausalito in their rush to the mining camps of the Sierra foothills, Richardson was forced to borrow heavily against the land. When, in addition, he suffered failed shipping investments, he fell deeply into debt. Desperate, he forfeited all but 650 acres of Rancho del Sausalito's remaining acreage to his wily lawyer, Samuel Throckmorton. By the time of his death in 1856, he had been stripped of most of his assets. The Richardson heirs, one of whom was interviewed in the *San Francisco Call-Bulletin* as late as 1918, lived out their lives in greatly reduced circumstances.

Sausalito sits today on Richardson's Bay, named for British seaman William Antonio Richardson, pictured here in 1854. Richardson's dramatic story exemplifies the range of fortune, for good and ill, that awaited many during the volatile years of mid-19th-century California. Richardson's vision for Sausalito was ambitious—he foresaw but never achieved a city equal in size to Yerba Buena, Mexican forerunner of San Francisco.

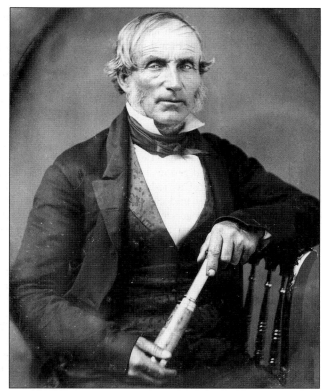

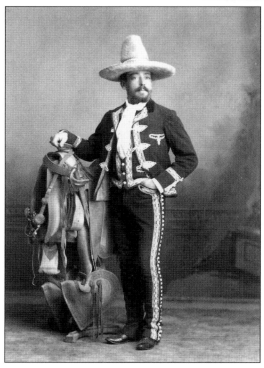

In pre-gold rush days, people of Spanish descent born in Alta California were called "Californios." Many were upper class, often holders of vast land grants awarded by the Mexican government. Others worked as cowboys (vaqueros) on the large ranchos, as the young man in this photograph may well have done. The social life of William Richardson and his family largely centered on their friendships or blood ties with this landed class, often taking the form of week-long celebrations and fiestas around the bay.

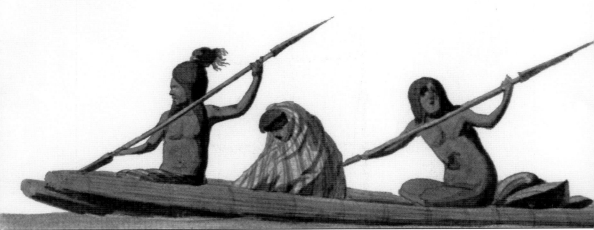

For possibly half a millennium, the place now called Sausalito was occupied by hunter-gatherers known today as the Coastal Miwok. Depending where they lived in the area, they subsisted by hunting, fishing, or foraging. Armed with bows and carrying quivers made from the skin of sea otters, they could catch fish, birds, rabbits, squirrels, deer, and bear with great skill. Sausalito, which they called *Lewan Helowah* or West Water, was home to at least seven of these small, self-contained villages. You can scarcely dig below the surface of some parts of town, especially in the Turney Valley area, without uncovering arrowheads, domestic artifacts, even "middens," ancient refuse heaps or burial mounds. The Miwok continued to prosper until the Spaniards established a permanent presence in the Bay Area, effectively destroying the native Indian culture. By the end of the 1800s, all the Sausalito villages were gone. And while many individuals of mixed Miwok/Pomo heritage remained (and still do) in the North Bay region, and in the past decade have regained U.S. government recognition as an official tribe, only a handful of full-blooded Coastal Miwoks were still living by 1900. Today there are none.

OPPOSITE: During William Richardson's heyday as owner of the vast Mexican land grant, Rancho del Sausalito, whaling ships bound for the Pacific were attracted to the protected cove and deep-water anchorage off Old Town, also known as Whaler's Cove or Shelter Cove. From that safe harbor, immediately inside the Golden Gate, they enjoyed easy access to Richardson's supplies of fresh beef, spring water, and seasoned lumber. On the *Gay Head* we see men laid out on the main topgallant yard of a typical mid-19th-century whaler, rigged as a bark. She seems to be flying Old Glory, indicating that the undated photograph was taken after 1850, when California became a state. Note the giant wooden davits holding the carvel-planked whaleboat, as well as the covered open area on the stern where the ship's wheel was located. (Courtesy San Francisco Maritime Museum.)

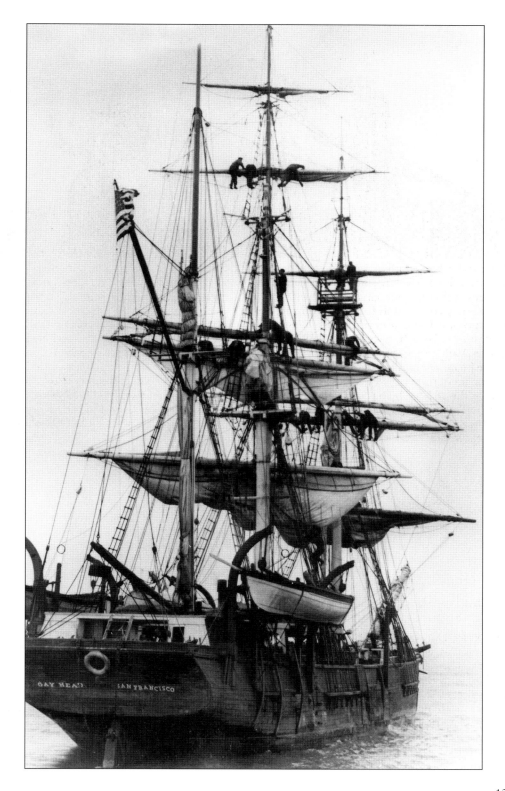

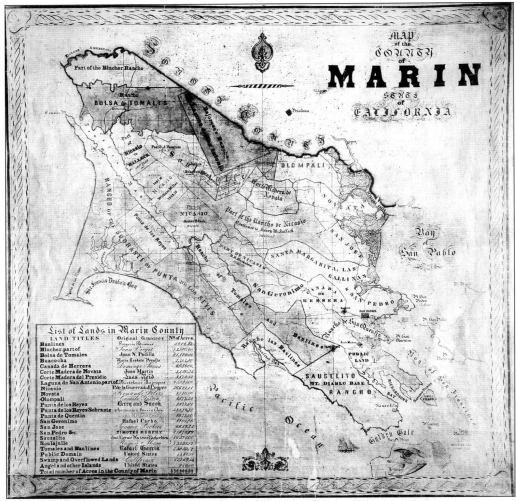

This map of Marin County was registered in San Francisco on November 6, 1861. It illustrates the legacy of ranchos granted to individuals during the Spanish and Mexican periods. In the inset box are listed the names of the ranchos, their owners, and the exact size of each parcel. After California became the 31st state in 1850, the U.S. Land Commission reviewed the legitimacy of each land grant. Richardson retained his title, but many grantees whose records were less meticulous lost all their rights. Almost all grantees incurred large debts to pay attorney fees, other litigation costs, or new land taxes. (Courtesy California Historical Society.)

A wagon pauses on Sausalito Boulevard above Old Town in the 1880s. Sausalito Boulevard was originally cut to improve access between New Town to the north and Old Town to the south, in hopes that it would stimulate the sale of lots in Old Town. But buyers continued to prefer New Town because it was serviced by the railroad from the north and ferries from the south. Angel Island is seen across the water beyond the modest development on the shore of Old Town.

The Pacific Yacht Club, with its massive flagpole, anchors the southern end of Old Town in this 1882 photograph. At the lower left is the manganese smelter that processed ore from the local hills. Very few homes had been built since 1852. In that year, most local structures were torn down and sold for the value of their lumber, responding to a demand for building materials after a disastrous fire in Sacramento.

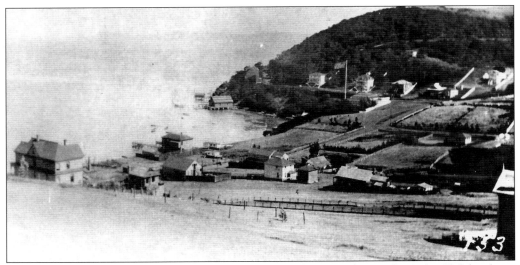

Ten years later, in 1892, many changes have come to Old Town. The Pacific Yacht Club has been transformed into a private residence, still with its flagpole, for Claus Spreckels and his family, who escaped here from the heat and dust of their Salinas Valley sugar beet–processing empire. The nearby boathouse with the striped roof protects the family's yacht, the *Lurline*, and houses its crew. Behind the Spreckels's home on the hill, mansions are springing up along the road to Fort Baker.

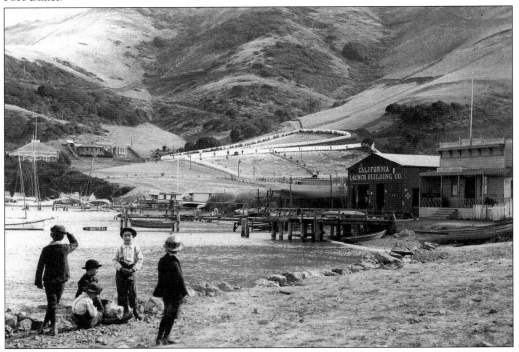

In another 1892 view of Old Town, the smelter has been replaced, at far right, by Cottage By the Sea, a popular bar of the period. Between it and the California Launch Building Company runs Water Street, as yet unpaved. The photograph was skillfully posed with the boys in the left foreground and the hills in the distance to enhance the perspective and drama of the scene.

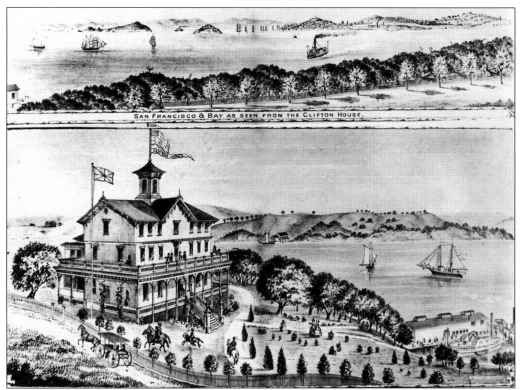

SAN FRANCISCO & BAY AS SEEN FROM THE CLIFTON HOUSE.

Originally a guesthouse overlooking the best bay views, Clifton House began as early as 1869, the year after the Sausalito Land and Ferry Company launched its ambitious development plans. By the late 1870s, it was a grand hotel. It offered over 100 luxury suites to encourage long stays and to stimulate real estate investment. Note the ferry landing nearby, offering easy access to the hotel. In 1904, the building was demolished.

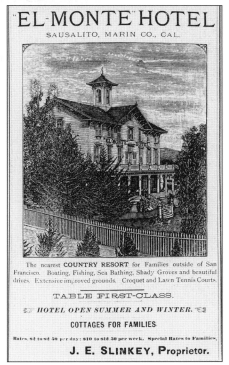

"EL-MONTE" HOTEL

SAUSALITO, MARIN CO., CAL.

The nearest **COUNTRY RESORT** for Families outside of San Francisco. Boating, Fishing, Sea Bathing, Shady Groves and beautiful drives. Extensive improved grounds. Croquet and Lawn Tennis Courts.

TABLE FIRST-CLASS.

☞ *HOTEL OPEN SUMMER AND WINTER.* ☜

COTTAGES FOR FAMILIES.

Rates, $2 to $2.50 per day; $10 to $12.50 per week. Special Rates to Families.

J. E. SLINKEY, Proprietor.

Clifton House has now become the El Monte Hotel, which promoted itself as a first-class resort for families. J. E. Slinkey, the energetic owner and proprietor in the 1880s, catered to a distinguished San Francisco guest list. He also kept a hand in local politics and was part owner of the *Sausalito News*. He managed two hotels, the one on the hill shown here, and a more modest one on the waterfront when times were bad. (Courtesy California Historical Society.)

17

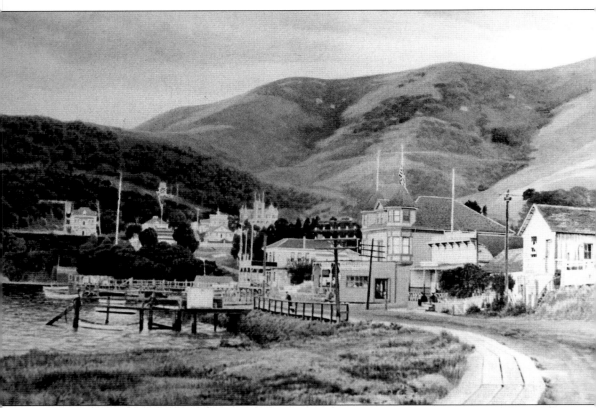

Ten years later, in 1902, a building boom has hit Old Town. The Jack London House, the turreted two-story Victorian where the famous writer is said to have penned pages of *Sea Wolf*, is across the street from the Cottage by the Sea bar. The famous Walhalla *biergarten* has been added to the waterfront, and in the distance, two large mansions are poised on the hill for maximum views. Both only lasted a few years before being destroyed by fire. Other signs of the times are telephone and electrical poles, as well as a boardwalk for pedestrians. In this rendering, an artist has touched up the photograph, eliminating unsightly utility wires from view.

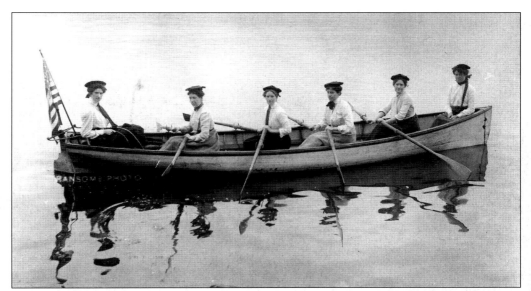

Thomas Wosser, first engineer on the ferryboat *Princess*, and his wife had five sons and nine daughters, six of whom are posed here in the family boat *Chepseta*. While none of them could swim, they were excellent oarswomen and rowed each evening, weather permitting, around Richardson's Bay, Angel Island, and sometimes out the Golden Gate. The girls are wearing "jack tar" hats given to them by the officers of the U.S. Revenue cutters the *Hugh McCullough* and the *Bear*, both stationed in Sausalito.

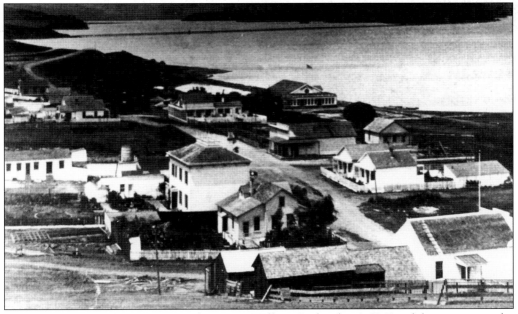

This is a rare view of New Town in the 1880s. William Richardson's 1840s adobe was just to the left of the low, white bunkhouse at middle left. By this time, only a single adobe wall remained of the home. The photograph documents the development of homes and businesses along Caledonia Street and the path of the North Pacific Coast Railroad across the tidal flats toward Mt. Tamalpais and the Pine Point train trestle.

STATE AND COUNTY TAXES FOR 1877-78,

In Road District No. 4, Marin County.

Nᵒ 1373

Office of the Sheriff and Tax Collector, County of Marin, State of California,

Received, SAN RAFAEL, Dec. 5th A. D. 1877, from Thomas Wosser

the sum of Eight and 80/100 Dollars, being the amount of STATE AND COUNTY

TAXES for the fiscal year ending June 30, A. D. 1878, upon the following described Real and Personal Property, assessed to the above named party, and for reference and full description of property see the Assessment Roll for the year 1877-78, page 467

DESCRIPTION OF PROPERTY.	VALUATION.	TAX.
Real Estate, other than City or Town Lots		
Improvements thereon		
Town Lots Lot 5 in Block 11, Town of New Saucelito.	250	
	300	
Improvements thereon		
Improvements on Real Estate assessed to other than the owner		
Personal Property		
Total Amount,	550	8 80

Amount of Tax on $100 Valuation.

State Fund	6t.
General County Fund	30
Road and Bridge Fund	28
Road Bond Interest	05.3
Court House Bond Interest	05.1
Road and Bridge Bond Interest Fund	02
Infirmary Fund	04.8
School Fund	06
Railroad Bond Interest	14.4
Total	$1 80

James Tunstead

Tax Collector Marin County.

By R. H. Kotche

Deputy Tax Collector.

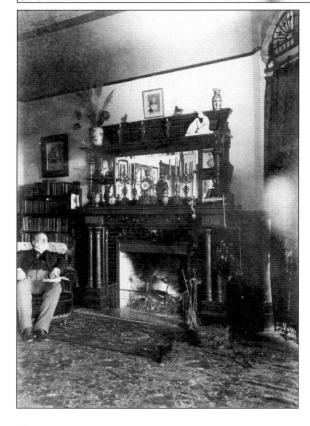

Rising taxes are nothing new. Thomas Wosser's 1877–1878 state and county tax bill called for an additional $3.70 due on his lot and improvements, representing a 42 percent increase from his 1874–1875 tax bill. Wosser, an Irishman and the first of five generations of Wossers to serve on ferryboats, built one of the first houses in New Town. Members of the Wosser family continued to live in the house until 1981.

In this c. 1889 photograph, Charles Harrison, a founder of the Sausalito Land and Ferry Company, sits in the library of Hazel Mount, his mansion. Harrison devoted himself to the development of a progressive town with paved streets, utilities, and efficient services. His dream was realized in 1893, when Sausalito was incorporated and resources became available for modern improvements. Harrison lived in Sausalito until his death in the early 20th century.

Bewildered residents and shopkeepers survey the charred remains of 10 buildings, almost the entire Sausalito business district. On the Fourth of July 1893, a stray firecracker, thrown from the El Monte Hotel on the hillside above, ignited the roof of a saloon on Water Street. Before the flames could be controlled, all the surrounding buildings had been destroyed. The disaster befell the town shortly before it was incorporated in September of the same year, probably spurring on the effort to generate resources and a legal framework for such community improvements as the Sausalito Volunteer Fire Department, which was organized in 1909.

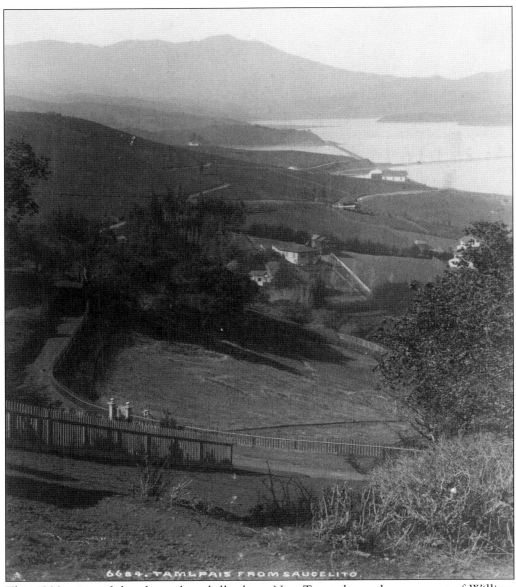

6684. TAMLPAIS FROM SAUСELITO.

This 1880s view of the almost bare hills above New Town shows the area west of William Richardson's former adobe. Two of the oldest surviving homes in Sausalito are clustered near the grove of trees in the center of the photograph. Madrona Cottage, the smaller of the two, was built in 1874 as a wedding gift for the daughter of John Romer, a partner in the Sausalito Land and Ferry Company. The slightly larger Elderberry Cottage dates from 1876. Although no cows appear in this photograph, the fenced areas define the cow pastures. The trees that grace Sausalito's hillsides today were almost nonexistent in the 19th century, having been largely planted in the last 100 years. In the distance, the railroad trestle leading to Strawberry Point can be seen going off to the right. Along the shoreline, the tracks of the North Pacific Coast Railroad, heading south over what was then tidal marshes fronting the area known today as Whiskey Springs, make their way downtown. As in all north-facing views of the town, Mt. Tamalpais defines the horizon. (Courtesy Bancroft Library.)

Two

OLD TOWN, NEW TOWN, DOWNTOWN

BY PHIL FRANK

Princess Street by Sutton Wood.

Seven years before William Richardson's death, he sold 650 acres of Rancho del Sausalito (Old Town) to another man with a vision, a San Francisco lawyer named Charles Tyler Botts. By the early 1850s, that critical strip of land, with its deep-water cove and proximity to the Golden Gate, had undergone a series of grandiose, but unrealized development schemes. One of these, based on the potential for a U.S. Navy sawmill at Shelter Cove, envisioned a future city of 100,000, rivaling San Francisco. On that premise, a nascent town sprang up, which Botts named "Old Saucelito," a spelling which persisted until the late 19th century. A related vision was the short-lived notion of Navy personnel stationed in San Francisco to develop Old Town as the future U.S. Navy Yard on the West Coast. In 1852, that honor went to Mare Island, and "Old Saucelito," or New Town, remained a backwater.

In 1868, however, 19 San Francisco businessmen flush with gold-rush profits bought 1,164 acres of William Richardson's former rancho from Samuel Throckmorton (Richardson's attorney)

and his associates for $440,000. A year later, nine of them formed the Sausalito Land and Ferry Company and initiated ambitious development plans. They subdivided the central hills and waterfront into building lots and started ferry service from San Francisco for prospective buyers. Their plans largely stagnated until 1875, when a narrow-gauge rail line from the north, begun two years earlier, was completed, and the first locomotive of the North Pacific Coast Railroad rolled into Sausalito. The railroad inaugurated ferry service to San Francisco, and overnight the town became a transportation hub, linking Marin County and points north to the south bay. The resulting real estate boom irrevocably changed Sausalito, molding its history well into the 20th century.

The town that emerged—informally consisting of Old Town, New Town, and Downtown—tended to be divided by topography, climate, and social class. Sausalito is made up mostly of steep hills, with two gently sloping valleys that run down to the bay and end as two coves. The early isolation and stagnation of New Town and Shelter Cove was due, in part, to these natural barriers.

The residential community that developed around the northerly cove in the 1870s soon acquired the name of New Town. Although several of the oldest surviving and most elegant Sausalito residences still standing are in New Town, early on this area attracted local train and ferryboat workers, as well as a strip of service businesses that became Caledonia Street.

Downtown and its Water Street commercial district grew quickly with the introduction of the ferries, followed by the arrival of the railroad. Along the waterfront, a hearty, and often rowdy, working-class community of saloons, poolrooms, and main street businesses developed. At the same time, as residential lots sold in the hills above, wealthy San Franciscans—among them many upper-class British expatriates—built summer homes and showplace mansions. Blessed by a balmy micro-climate, The Hill, as this area was known, was dubbed "The Banana Belt."

By the 1880s, Sausalito as a town had taken root, and in 1893 it was incorporated as a city bearing its present-day spelling, which had been made official in October 1888. No longer a working rancho, and never having become a second Bay Area metropolis, mill town, or naval base, it began its slow evolution into the place it is today. Along the way, it incorporated traces of its many past incarnations: fishing and boat-building village, upper-class retreat, transit center, working-class neighborhood, bootleggers' hideout, World War II shipyard, artists' colony, yachting community, and residential enclave.

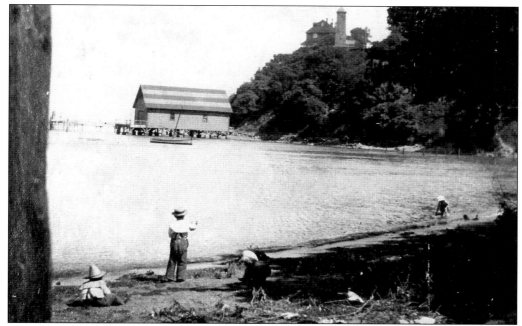

This delightful scene shows four bonneted children playing on the Old Town beach. The Spreckels boathouse dominates the image, with an Italian felucca tugging at anchor nearby. On the hillside is Craighazel, one of many grand mansions springing up on Sausalito's hillsides in the late 19th century. Owned by Col. John Dickenson (an attorney and San Francisco socialite who served as president of the original Sausalito Board of Trustees), it was built in 1890.

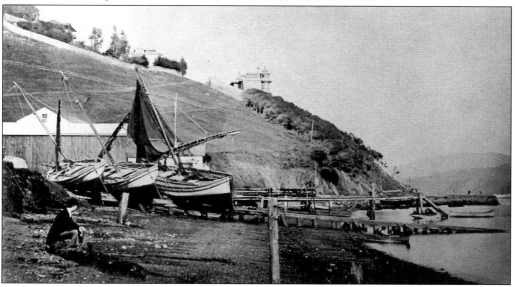

The Old Town waterfront was photographed by English photographer Eadweard Muybridge in about 1885. William Randolph Hearst's Sea Point mansion, with its striped and turreted roof, is silhouetted against the sky and surrounded by the estate-dotted hillside above the south-central waterfront. That area would become known as the "Banana Belt" for its semi-tropical microclimate, making it highly desirable as Sausalito's prime, upscale neighborhood.

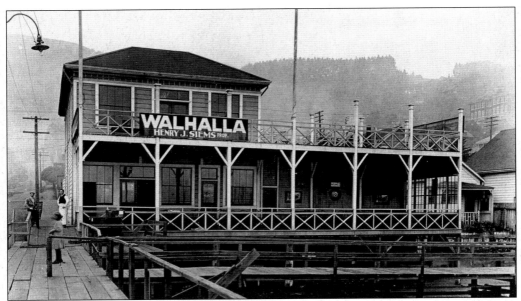

The Walhalla was constructed in 1893 on the former site of the Sausalito Smelting Works. A popular German restaurant and *biergarten*—even during Prohibition—it languished, empty, after World War II, until former San Francisco madam Sally Stanford took it over in the late 1940s and created the Valhalla restaurant. This photograph, taken in 1910, shows proprietor Henry J. Siems, who leased it for five years from its original owner, Joseph "Al" Lowder.

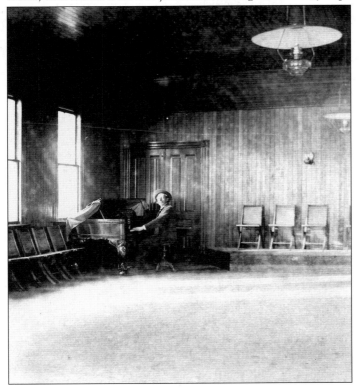

In 1900, when this photograph was taken, the upstairs room of the Walhalla *biergarten* was used for dancing and entertainment. Furnished with kerosene lamps, folding chairs, and a piano, it served as the only space large enough for the Old Town neighborhood to gather for civic and festive occasions. The gentleman at the piano is believed to be Al Lowder, the original owner and operator of the popular establishment.

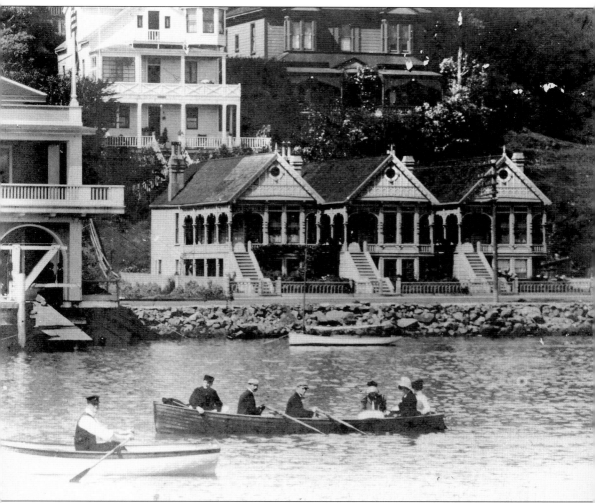

The Three Sisters, as these waterfront rental cottages were known, brought a residential air to the edge of the downtown commercial district with its bars, poolrooms, and busy ferryboat terminal and train depot. The cottages —named Lolita, Lucretia, and Lurline— were located just north of the San Francisco Yacht Club, across Water Street. Two remain today. In 1914, Lurline was demolished to make way for the town's new telephone exchange.

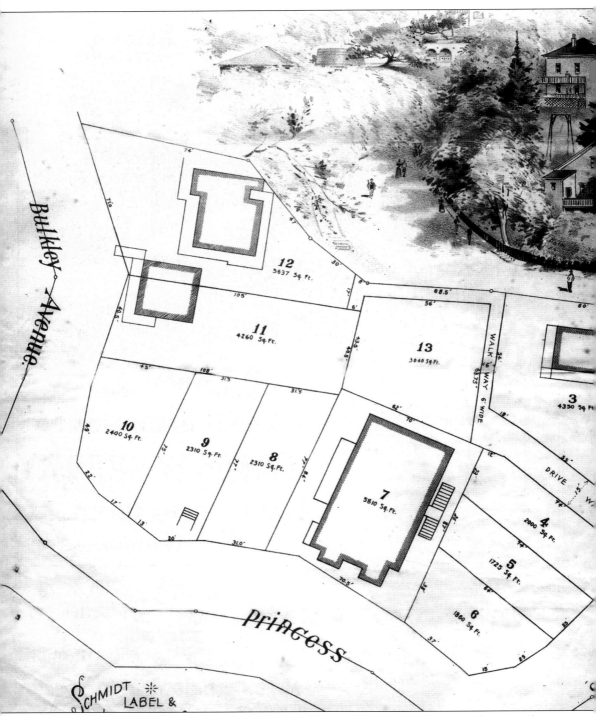

This 1893 handbill for the sale of property on Princess Street provides not only a map but a delightful lithograph showing pedestrians, horses and stage, and a gentleman on a "penny-farthing" bicycle. The buildings were all owned and offered for sale by Maj. James Sperry, owner of the

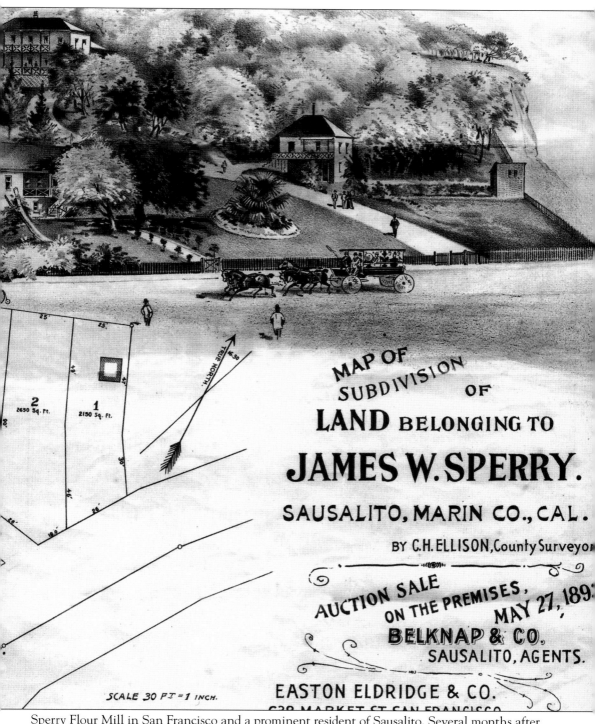

MAP OF SUBDIVISION OF LAND BELONGING TO

JAMES W. SPERRY.

SAUSALITO, MARIN CO., CAL.

BY C.H. ELLISON, County Surveyor

AUCTION SALE ON THE PREMISES, MAY 27, 189?

BELKNAP & CO.

SAUSALITO, AGENTS.

EASTON ELDRIDGE & CO.

SCALE 30 FT = 1 INCH.

Sperry Flour Mill in San Francisco and a prominent resident of Sausalito. Several months after the handbill appeared, the town voted for incorporation, and the new board of trustees picked James Sperry as the first mayor of Sausalito.

Taken on Bulkley Avenue in the 1890s, this photograph shows John Perry, the gentleman in the cart, who hired out horse teams and did work for many of the owners of Banana Belt estates. The woman with her back to the camera is Phoebe Apperson Hearst, a major California philanthropist, wife of Sen. George Hearst, and mother of William Randolph Hearst.

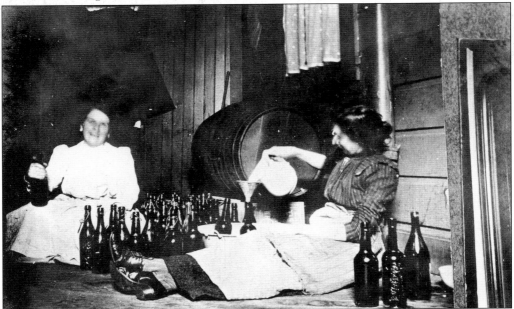

Many early immigrants to Sausalito brought their traditions of wine making and beer brewing with them. This photograph, probably taken about 1890, shows two members of the family of French merchant Jean Baptiste Baraty filling bottles from a wine barrel. The barrel is sitting, like the ladies, in the hallway of the family's downtown business.

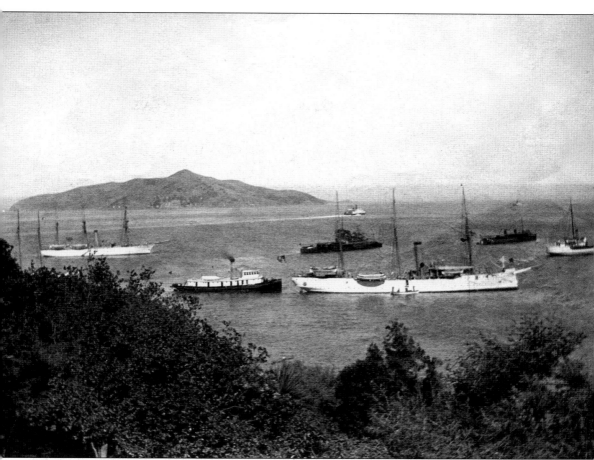

This view from the hills above Old Town toward Angel Island illustrates how convenient it was for both government and commercial ships to make use of Sausalito's safe anchorage, directly inside the Golden Gate. The two, large, white-hulled ships are the U.S. Revenue cutters *Thetis* on the left and the *Hugh McCulloch* in the center. A tug steams toward the *McCulloch*. The dark-hulled ships are military craft, and on the far right is a steam schooner designed to pick up lumber from yards along the Northern California coast.

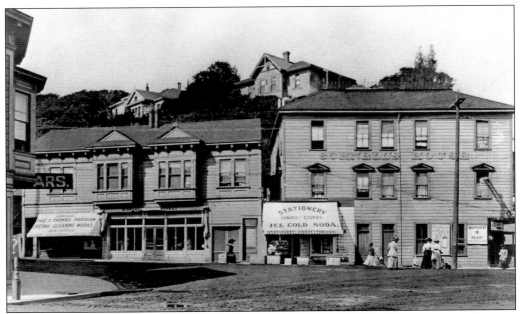

At the turn of the 20th century, the intersection of Princess and Water Streets was the heart of the Sausalito downtown business district. Its numerous bars and poolrooms—and the fact that Sausalito was a transit hub for trains, ferries, and transients headed both north and south—made it a mecca for travelers and entertainment seekers. Downtown, in response, provided them what they wanted: food, drink, and fun.

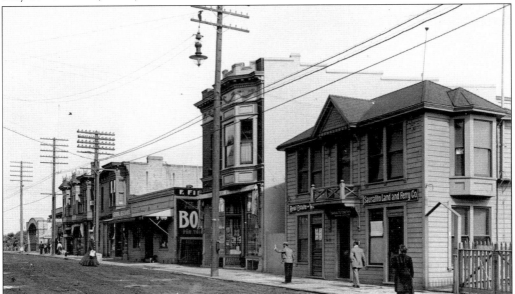

The shore side of Sausalito's downtown business district is captured in this glassplate print from about 1910. Note that the street is still dirt, with pot holes and mud puddles. Incorporation in 1893 brought street lamps, electricity, and telephone lines, but Water Street remained unpaved. Paving came in the 1920s, and a new name, Bridgeway, followed in the late 1930s with the building of the Golden Gate Bridge.

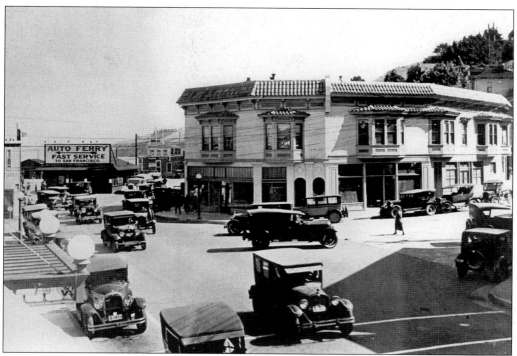

The arrival of the automobile in the 1920s had a great impact on Sausalito. Ferries turned into "auto ferries." Whereas previously the trains met the ferryboats, now the town was crowded with cars, waiting to board these hulking transbay vessels. Although a second ferry system sprang up to help move vehicles and people, automobiles still clogged Water Street, with traffic often backed up a mile or more north of town.

Cigars, Cigarettes
Candies

M & M POOL HALL

1045 Water St.

SAUSALITO, CALIF.

MARCO MELS-ICH, Prop.

Tel. Sausalito 315

CLOSE COVER BEFORE STRIKING MATCH

In the early part of the century, the downtown business district was studded with so-called "pool halls." But that was a misnomer. Billiards and eight-ball weren't played there. They became the scene of "betting pools," organized around telegraphed reports of horse races underway around the country. The town became bitterly divided over the issue. Finally, in 1909, off-track betting was outlawed, and the M & M, memorialized by the matchbook cover seen at right, became a billiard hall again.

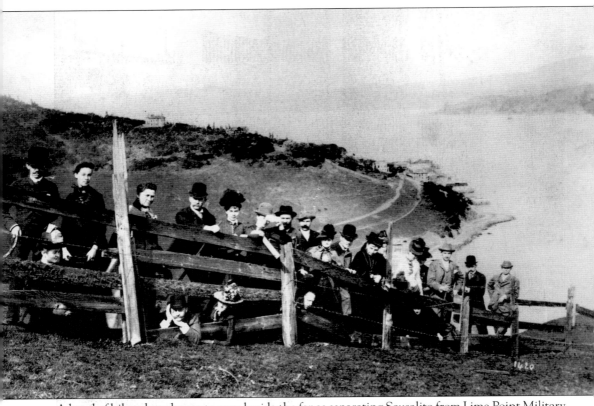

A band of hikers has chosen to pose beside the fence separating Sausalito from Lime Point Military Reservation in this 1890s group portrait. The military reservation was eventually named East Fort Baker. In the background, Sausalito is beginning to take shape. At the bay's edge, Water Street has been filled and leveled, and hotels and piers are appearing in the downtown area. A sprinkling of estates on the hillside indicates that affluent people are putting down roots.

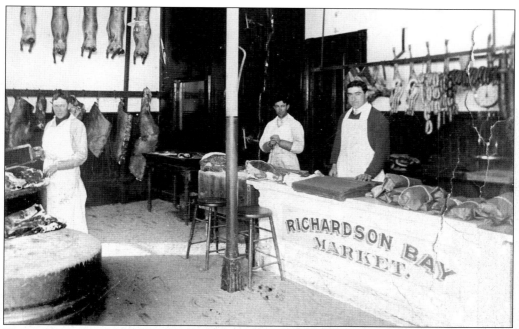

During the early 1900s, these Richardson Bay Market butchers are busy inside their store on Princess Street. Packages wrapped and waiting on the counter will soon be loaded into their wagon to be delivered to homes on the hill. Orders were telephoned in or dropped off by school-bound children or husbands heading to the ferry for the morning boat to San Francisco.

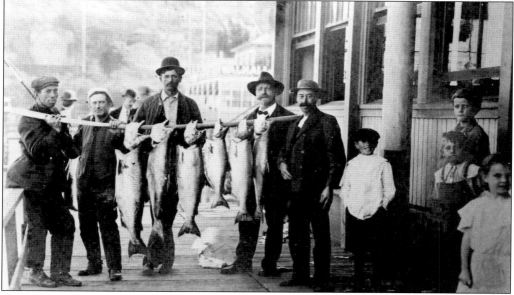

The catch-of-the-day in this 1905 snapshot appears to be salmon, which weighs enough to bend the oar from which it's hung. The happy anglers stand on the boardwalk in front of Castle by the Sea, a corner saloon located beneath the building known today as Jack London House. London's habit of holing up there for weeks at a time while on a writing jag has long suggested the building's unofficial name.

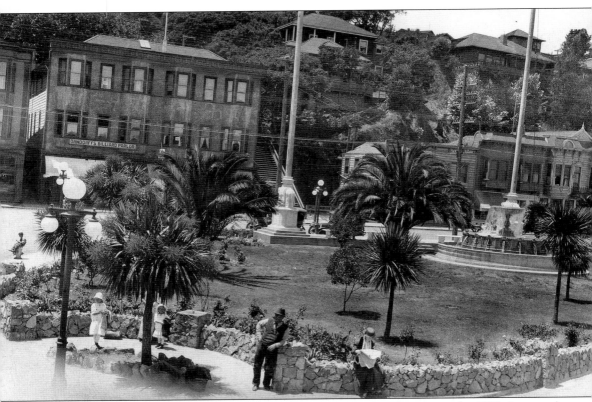

Depot Park, today known as Viña Del Mar Park, begins to develop character in this 1920 photograph. The elephant-based flagpoles and Italianate fountain, acquired in 1916 after the closing of San Francisco's Panama-Pacific International Exposition, are in place. The palm trees that now tower over the park are just beginning to grow. The people in the foreground are waiting for a ferry to San Francisco, or perhaps a train to San Rafael.

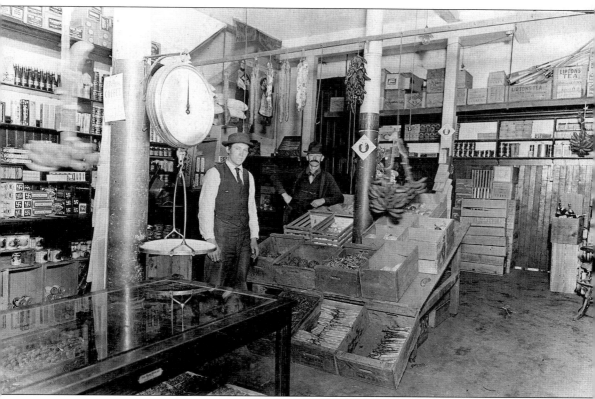

Scipio Ratto stands behind his assistant "Babe" Malone inside the grocery store Ratto co-owned with John Mecchi. Many of the businesses in Sausalito were owned by Portuguese or Italians. Several stores were owned by Chinese, and a couple by immigrants from France. Most of the hillside residents were British. Two very different populations, one from the hill and the other from the waterfront, got along surprisingly well—perhaps because they needed each other.

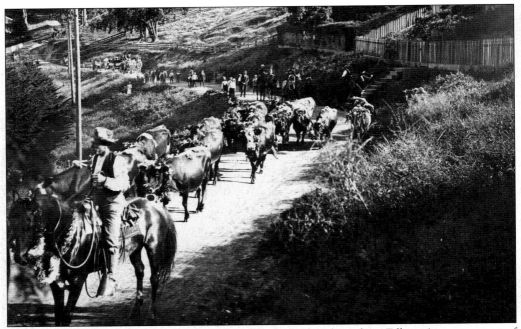

The flower-bedecked cattle in this 1900 photograph are parading along Filbert Avenue as part of the annual Portuguese Festival of the Holy Ghost on Pentecost Sunday, called *Chamarita*. The parade, still observed by descendants of the original immigrants, begins at Portuguese Hall on Caledonia Street, proceeds to Saint Mary Star of the Sea Catholic Church for mass, and returns to Portuguese Hall for a traditional meal of beef, soup, sweet bread, and wine.

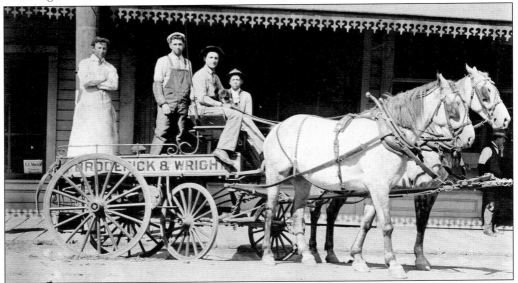

Broderick & Wright Grocery, the oldest grocery on Caledonia Street when this photograph was shot around 1912, delivered groceries throughout town with this wagon and team. Its place of business, still standing at Caledonia and Turney Streets, was converted to housing for shipyard workers during World War II. But it still contains a door which, when opened, reveals a white tile floor imprinted with blue letters. The words, a bit faded with time, spell out Broderick & Wright.

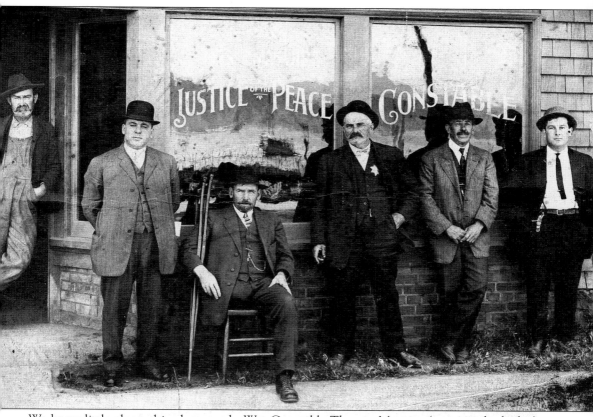

We know little about this photograph. Was Constable Thomas Maguire (wearing the badge) simply giving his prisoners some air? Or was he holding an important meeting with the town trustees? Who knows? All we can say for sure is that it has an unmistakable air of the Old West about it.

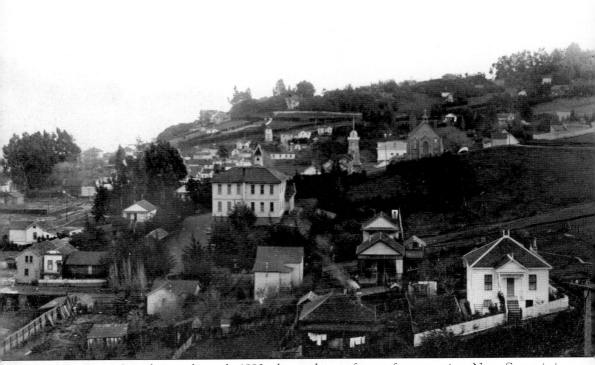

New Town Sausalito in the early 1890s shows plenty of room for expansion. Napa Street is in the foreground. Prominent at the center of the picture, Central School, which had just opened, served Sausalito until 1926, when it was moved a half-block downhill to Caledonia Street. Today it's still in service, housing the local hardware store and bicycle shop, among other things. Sausalito retained a distinctly rural feel well into the 1900s. A major civic issue in the 1880s was destruction of gardens by wandering cows. Fences were rare, and errant roosters and pigs were not uncommon sights. There were no streetlights on the hillside byways, which meant people visiting neighbors carried lanterns after dark. This view looks south toward downtown. On the other side of the hill is Old Town.

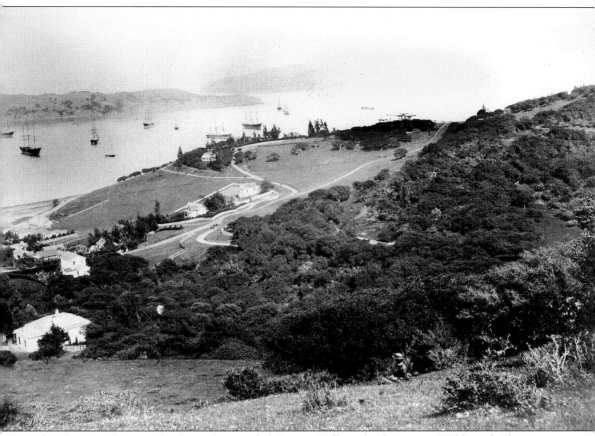

The photographer stands above the wooded Turney Valley, also known as Wildwood Glen, or simply The Glen, about 1880, capturing a portrait of land and water. Numerous square-rigged grain ships ride at anchor in Richardson's Bay. On the left, New Town is developing around Caledonia Street. On the hillside, only a few estates can be seen. In the center, "Five Corners," a point where five roads converge, is already clearly delineated. These roads still converge today—San Carlos, Bulkley, Harrison, Glen Drive, and Santa Rosa.

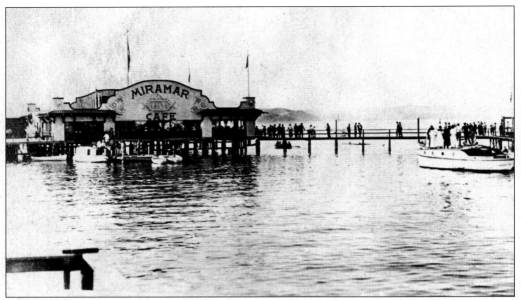

The tidal flats of Richardson's Bay were sold by the state in 1881, with Sausalito retaining ownership of the underwater "streets" between the parcels. Since those who bought tideland properties could operate businesses there, restaurants on pilings, yacht harbors, and boatyards sprang up on the waterfront. The Miramar Cafe, shown here, was built in 1910 and burned in 1911. It was rebuilt in 1912, and burned again in 1915. That time the owner went to jail for arson.

A happy group poses in the New Method Laundry wagon on Caledonia Street. New Method was owned by the Elliot family, who also published the *Sausalito News* for many years. The Elliots employed the same spring-fed creek waters that William Richardson's household servants used to wash the family's laundry back in the 1840s. New Method operated at the same location until 1977.

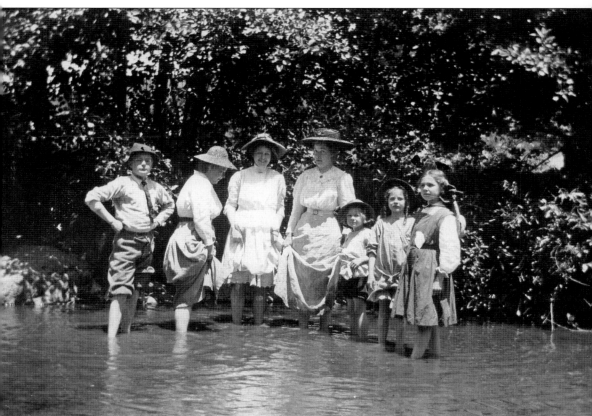

Members of the Ritchie family, who lived on Cazneau Street, enjoy a cool wade in the Wildwood Glen on a warm summer day in 1912. Music and singing would often filter through the Glen from an open-air dance floor and dining area built above the spring-fed creek, where families from throughout the Bay Area often came to enjoy picnics and dancing.

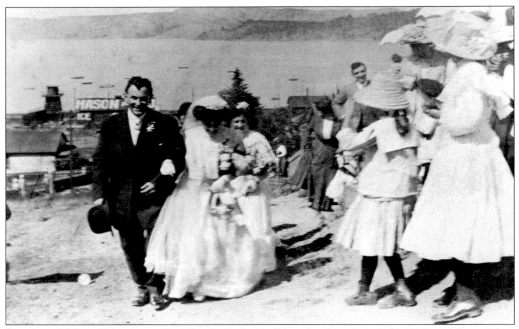

Frank and Mary Silva leave St. Mary's Catholic Church after their July 1910 wedding. Silva, a skilled carpenter, built their home on Tomales Street. Many New Town residents of that era worked with their hands—in the railyards and boat shops, on the ferries, or in Mason's Distillery, whose prominent sign can be seen behind Frank. The house Frank built for Mary is still lived in today and looks much the same.

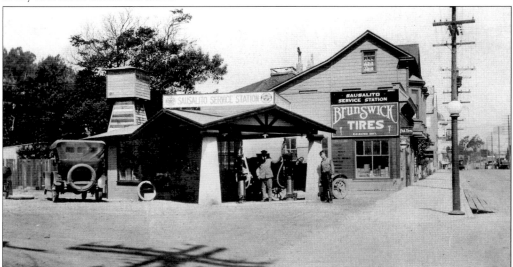

This lovely image of the intersection of Caledonia and Johnson Streets in about 1920 shows an early Sausalito service station with a couple of flivvers getting needed attention. A service station remained at this site throughout the era of auto ferry service, eventually becoming the home of a Flying A station. Vehicles would line up down Caledonia Street, inching their way toward the waiting ferries. Even today, although that use has changed, the structure at the corner still has the look and feel of a gas station.

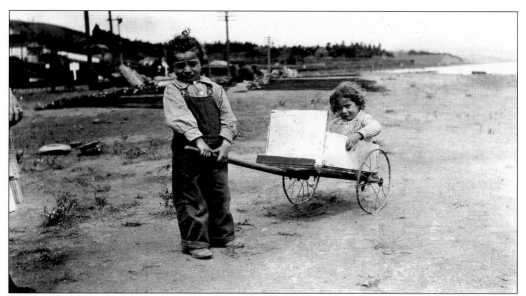

The Sausalito waterfront was for many years the playground as well as the training ground for Italian, Greek, and Portuguese children. Their fathers built, repaired, and maintained every kind of craft that floated on Richardson's Bay, including fishing boats, tugs, yachts, barges, and arks (houseboats). Some of their families fished the bay and ocean waters. Here Frank and Ettore Bregante pose with their wagon made from a champagne crate.

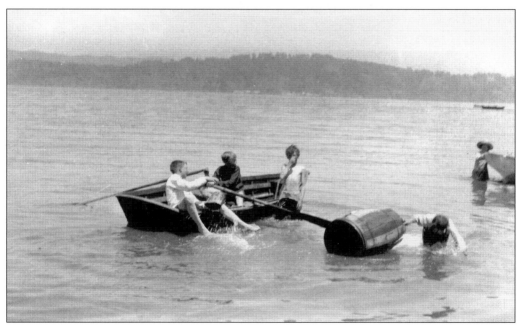

For years, kids in Sausalito were either from the Hill or the waterfront. Kids who grew up on arks and aboard boats took pride in their label—water rats. In fact, they may well have had more fun than their counterparts at the higher elevations, as this 1910 photograph taken from the Napa Street pier suggests.

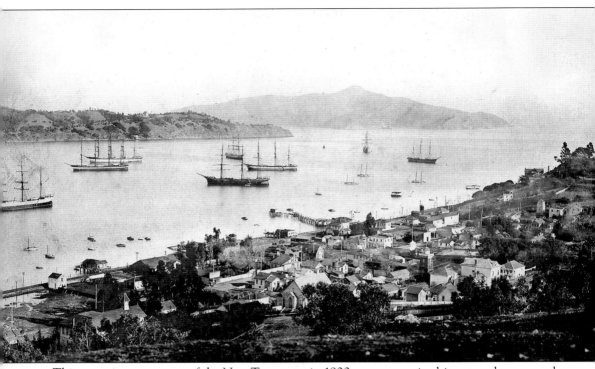

This sweeping panorama of the New Town area in 1900 captures grain ships at anchor, a couple of early houseboats hugging the shoreline, and the bustling residential and commercial area surrounding Caledonia Street. Saint Mary Star of the Sea Catholic Church sits at the corner of Litho and Bonita. In the background, Angel Island can be seen on the right and the Belvedere peninsula on the left.

Three

FERRYBOATS, TRAINS, AND TRAFFIC

BY WOOD LOCKHART

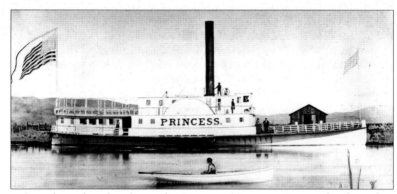

Sausalito's first ferryboat, the *Princess*. (Courtesy Bancroft Library.)

Until the completion of the Golden Gate Bridge in 1937, ferryboats provided the only means of public transportation between San Francisco and Marin County. Sausalito, the nearest Marin County neighbor to that larger city across the bay, owes its early development to its then role as the link between ferry service to and from San Francisco and rail service throughout Northern California. Although today visitors from San Francisco still arrive in Sausalito by ferryboat, the railroad is a distant memory.

Ferry service between San Francisco and Sausalito began in 1868 when the Sausalito Land and Ferry Company was organized and began selling residential lots to wealthy San Franciscans seeking a rural retreat. To provide transportation for the new homeowners, the company purchased a small paddle-wheel steamer, the *Princess,* and inaugurated a daily, round-trip schedule.

In 1875, the North Pacific Coast Railroad introduced narrow-gauge rail service to Sausalito which connected the town to other communities throughout Marin County. In the same year,

the North Pacific Coast also took over the ferry service, replaced the *Princess* with a larger boat, and moved the Sausalito terminal from Princess Street to a newly constructed railroad and ferry wharf in the center of Sausalito's downtown—in what today is the parking lot adjacent to the Plaza Viña del Mar. At the time, the plaza area was an open arm of the bay between the wharf and the shore. As the wharf was extended, this small body of water turned into a stagnant backwash and became infamously known as "the pond."

When the North Pacific Coast was reorganized as the North Shore Railroad in 1902, the mayor of Sausalito persuaded the company to fill in the unsightly "pond" and create a landscaped park in its place. Originally called Depot Park, Plaza Viña del Mar has evolved into one of Sausalito's most beloved landmarks. The North Shore Railroad also improved the wharf area by tearing down the old train shed and constructing a new, two-story terminal building. Standard-gauge track was added. In 1903, the North Shore installed an additional rail to allow electric train commuter service from Sausalito to Mill Valley, San Anselmo, and San Rafael.

In 1907, the North Shore Railroad merged with several other North Bay rail companies to become the Northwestern Pacific Railroad. Operating both trains and ferryboats, the NWP ushered in the glory days of the rail and ferry era for Sausalito. By 1914, travelers arriving by ferry could connect to any one of 80 electric commuter trains or 11 steam trains that operated on a daily basis to cities as far north as Eureka.

By the early 1920s, the automobile had become the favored mode of transport for many travelers, and demand increased for automobile ferry service. In 1922, the Northwestern Pacific's monopoly on transbay travel was challenged when a rival, the Golden Gate Ferry Company, inaugurated auto ferry service from San Francisco to Sausalito, using the original ferry landing site at the foot of Princess Street. In an effort to compete, NWP converted the railcar ferry *Ukiah* to auto service, enabling it to carry 100 cars and 3,300 passengers. It was rechristened the *Eureka* and became the largest ferryboat ever to operate on San Francisco Bay.

The opening of the Golden Gate Bridge to automobile traffic in 1937 marked the beginning of the end of Sausalito's days as a major transportation center. On February 28, 1941, the *Eureka* made the last regular ferry run from San Francisco to Sausalito, and in November of the same year the Northwestern Pacific eliminated all passenger rail service to the town. Although freight rail service would continue until 1971, and passenger ferries, largely catering to the tourist trade, resumed in 1970, the era of trains and ferries as dominant themes in the life of the town was over.

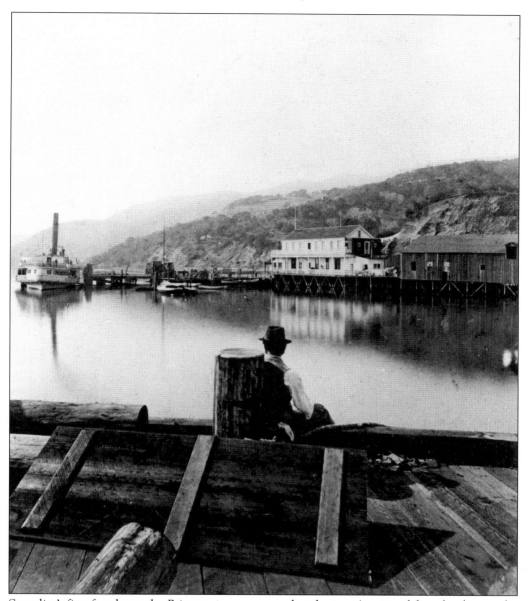

Sausalito's first ferryboat, the *Princess*, is seen moored at the town's original ferry landing at the foot of Princess Street, which was named for the vessel. Serving from 1868 until 1875, when she was replaced by the larger *Petaluma of Saucelito*, the *Princess* made two round trips a day from Sausalito to Meigg's Wharf at the foot of Powell Street in San Francisco. This photograph was taken in 1875 by famed English photographer Eadweard Muybridge.

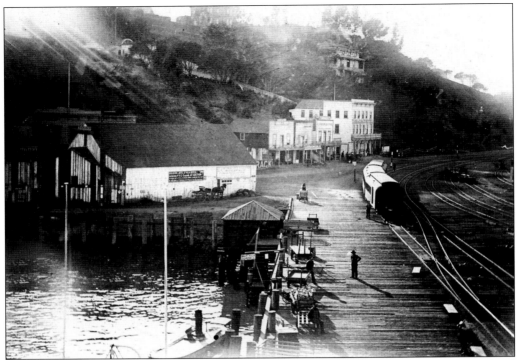

In 1875, Sausalito's ferry landing was moved from Princess Street to a newly constructed rail and ferry wharf, shown in this l888 photograph extending into the bay from Water Street (now Bridgeway). The Casa Madrona, built as a private mansion in 1885, is visible on the hill above the train.

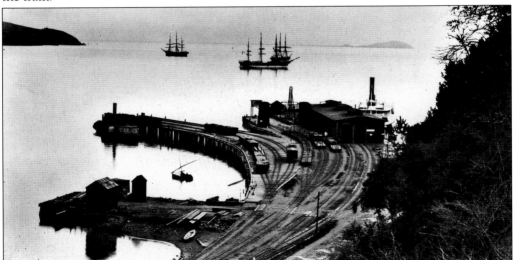

The Sausalito rail and ferry wharf, with its narrow-gauge track, is shown in this photograph from about 1890. The wooden train shed would be reconfigured in 1893 and placed across the end of the wharf to provide travelers with sheltered access to the ferryboats. The *San Rafael* is seen in the slip on the right, and in the background, three square riggers lie at anchor. (Courtesy Northwestern Pacific Railroad Historical Society.)

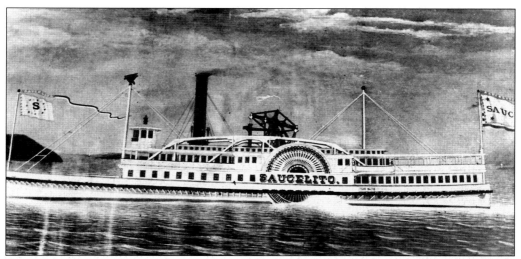

The *Saucelito* was named according to the town's accepted spelling of the time. Built in 1877, she was, like her sister ship the *San Rafael*, purchased by the North Pacific Coast Railroad as an elegant replacement for the earlier, more primitive ferryboats. Both ships were prefabricated in New York and sent by railroad cars to San Francisco for reassembly. On February 24, 1884, the *Saucelito* caught fire and burned while moored at the San Quentin ferry landing.

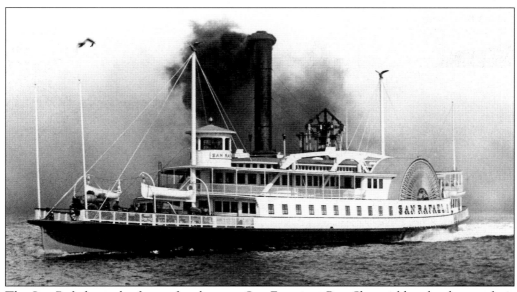

The *San Rafael* was the fastest ferryboat on San Francisco Bay. She could make the run from Sausalito to San Francisco in as few as 17 minutes. On November 30, 1901, while in heavy fog near Alcatraz Island, she was rammed by the much larger *Sausalito* (1894) and sank. Although two men and a horse were lost, over 200 passengers were saved. (Courtesy Northwestern Pacific Railroad Historical Society.)

North Pacific Coast R. R.
WINTER ARRANGEMENT.
IN EFFECT FROM SUNDAY, OCTOBER 22d, 1882,
— BETWEEN —
SAN FRANCISCO AND SAN RAFAEL.

LEAVE SAN FRANCISCO.	LEAVE SAN RAFAEL.
WEEK DAYS.	**WEEK DAYS.**
8.50 A. M. VIA SAUCELITO.	6.50 A. M. VIA SAUCELITO.
10.00 " " SAN QUENTIN.	8.00 " " SAN QUENTIN.
1.45 P. M. " "	*8.45 " " SAUCELITO.
*3.45 " " SAUCELITO.	12.00 M. " " SAN QUENTIN.
4.45 " " SAN QUENTIN.	2.30 P. M. " "
5.30 " " SAUCELITO.	3.15 " " SAUCELITO.
SUNDAYS.	**SUNDAYS.**
8.00 A. M. VIA SAUCELITO.	7.30 A. M. VIA SAUCELITO.
10.15 " " SAN QUENTIN.	8.50 " " SAN QUENTIN.
1.25 P. M. " "	12.00 M. " "
5.20 " "	4.00 P. M. " "
	5.00 " " SAUCELITO.

Trains marked (*) stop only at Saucelito, Lyfords, Ross Station, Junction and San Rafael.

BETWEEN SAN FRANCISCO AND SAUCELITO.

WEEK DAYS.		SUNDAYS.	
Leave San Francisco.	LEAVE SAUCELITO.	Leave San Francisco.	LEAVE SAUCELITO.
8.50 A. M.	7.45 A. M.	8.00 A. M.	8.45 A. M.
10.30 "	9.30 "	10.00 "	11.00 "
3.45 P. M.	12.30 P. M.	12.00 M.	1.00 P. M.
5.30 "	4.25 "	2.30 P. M.	3.15 "
		4.30 "	6.00 "

Extra Trips on Saturdays from San Francisco at 2.00 P. M., from Saucelito at 2.40 P. M. and 6.15 P. M. On Mondays from San Francisco at 7.00 A. M.

THROUGH TRAINS.

10.00 A. M. Daily, except Sundays, (via San Quentin Ferry) Through Train for Duncan Mills, arriving at San Rafael 11.15 A. M., Junction, 11.23 A. M., Fairfax, 11.38 A. M., San Geronimo, 12.09 ſ. M., Taylorville, 12.34 P. M., Tocaloma, 12.43 P. M., Olema, 1.05 P. M., Marshalls, 1.56 P. M., Tomales, 2.28 P. M., Valley Ford, 2.54 P. M., Bodega Roads, 3.05 P. M., Freestone, 3.12 P. M., Howards, 3.30 P. M., Russian River, 4.04 P. M., Duncan Mills, 4.20 P. M.

RETURNING Leave Duncan Mills **8.20 A. M.**, arriving at Russian River 6.40 A. M., Howards, 7.20 A. M., Freestone, 7.40 A. M., Bodega Roads, 7.47 A. M., Valley Ford, 8.02 A. M., Tomales, 8.38 A. M., Marshalls, 9.17 A. M., Olema, 10.03 A. M., Tocaloma, 10.36 A. M., Taylorville, 10.47 A. M., San Geronimo, 11.10 A. M., Junction, 11.47 A. M., San Rafael, 12.00 M., San Francisco, 1.10 P. M.

STAGE CONNECTIONS.

Stages leave Duncan Mills Daily, (except Mondays) for Stewart's Point, Gualala, Point Arena, Cuffey's Cove, Navarro, Mendocino City, and all points on the North Coast.

SUNDAY EXCURSIONS.
SAN FRANCISCO TO OLEMA AND RETURN.

8.00 A. M. Every Sunday from Saucelito Ferry, foot of Market Street, for Olema and Way Stations, arriving at Olema at 11.07 A. M. RETURNING, leaves Olema at **3.40 P. M.** and arrives in San Francisco (via Saucelito Ferry) 6.40 P. M.

Round Trip—Fairfax, $1.00, Olema $2.00.

SATURDAY TO MONDAY EXCURSIONS.

Excursion Round Trip Tickets, sold on Saturdays, good to return following Monday. **FAIRFAX, $1.00.** OLEMA, $2.50. TOMALES, $3.50. DUNCAN MILLS, $4.00.

DAVID NYE, General Superintendent.

F. B. LATHAM, General Passenger and Ticket Agent.

P. E. DOUGHERTY & CO., PRINTERS AND ENGRAVERS, 412 COMMERCIAL ST., S. F.

This "Winter Arrangement" of schedules and fares for the North Pacific Coast Railroad's ferries and trains took effect October 22, 1882. In that year, *Saucelito* was the accepted spelling of the town's name, as it had been on maps and official documents since shortly after California gained statehood in 1850. It was not until 1888, when the U.S. Postal Service officially designated Sausalito as the correct spelling, that the name of the town returned to what it had been on William Richardson's original 1838 land grant. (Courtesy of and copyright Moulin Studios.)

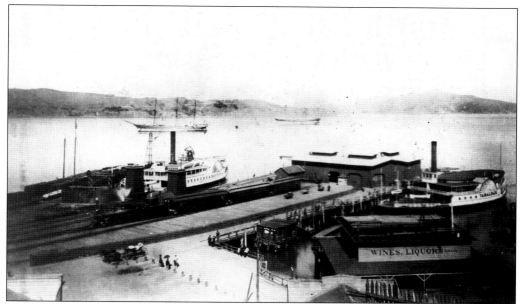

In 1893, the Sausalito rail and ferry terminal was expanded. In this photograph, the *San Rafael* is shown berthed on the left while on the right is the first *Tamalpais*, formerly named the *Petaluma of Saucelito*. As a result of the expansion, the water in the right foreground soon turned stagnant and became derisively known as "the pond." It would later be filled in to become today's Plaza Viña Del Mar.

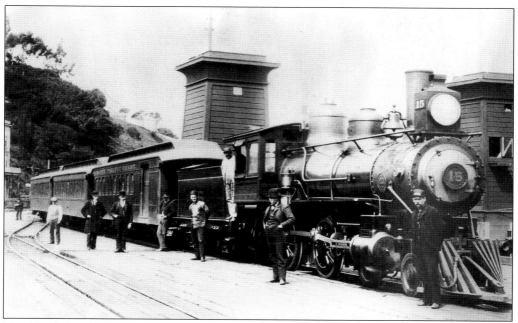

This North Pacific Coast passenger train and crew were photographed at the Sausalito rail terminal in 1893. The narrow-gauge locomotive No. 15 was built in 1891. In the background are the two towers of the freight slip, which contained machinery for raising and lowering the freight apron onto the rail car ferries. (Courtesy Sausalito Woman's Club.)

This photograph of the captain and crew of the *Sausalito* dates from the mid-1920s. Built for the North Pacific Coast Railroad in 1894, the *Sausalito* was the first double-ended ferry to operate between Sausalito and San Francisco. She gained dubious fame as the vessel that rammed and sank the *San Rafael* in 1901, a catastrophe immortalized in Jack London's novel *The Sea Wolf*.

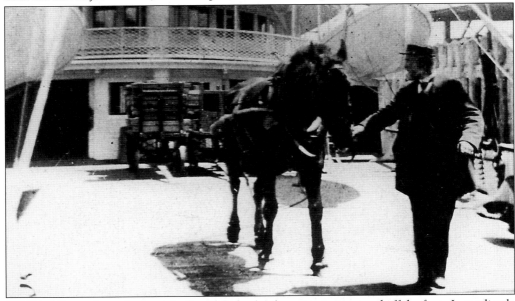

"Old Dick" was a horse kept on the *San Rafael* to haul express carts on and off the ferry. Immediately following the collision with the *Sausalito*, the two ferries were lashed together, allowing over 200 passengers to transfer to safety on the larger vessel. "Old Dick," however, refused to leave his home and went down with the ship. This photograph was taken from the foredeck of the *San Rafael* around 1900.

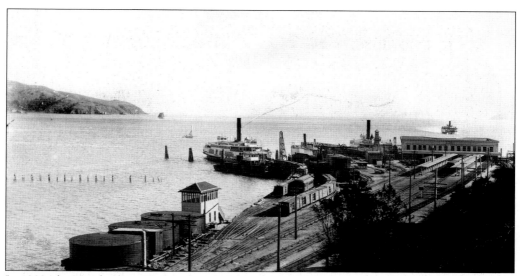

In 1903, the North Shore Railroad made improvements to the Sausalito rail and ferry wharf. A new two-story terminal building replaced the old train shed, and standard-gauge and electric track were added to provide electric commuter train service to points north in Marin. In this photograph, the ferryboat *Tamalpais* is in the slip at left, while the *Sausalito* approaches on the right.

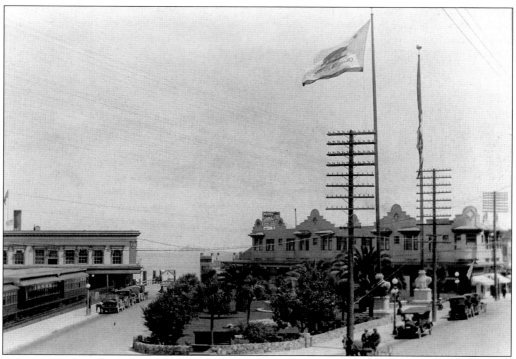

Depot Park, today's Plaza Viña del Mar, was created in 1903 when the odiferous "pond" was filled by the North Shore Railroad as part of a major renovation of the rail and ferry wharf. The railroad and ferry terminal to the left was built the same year, and the Mission-style Sausalito Hotel, which still stands today, was constructed in 1915 to cater to train and ferry travelers.

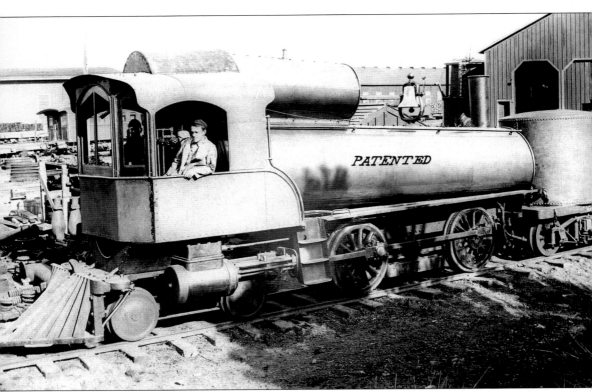

Nicknamed "The Freak," locomotive No. 21 was designed and built in 1901 by master mechanic William Thomas in the Sausalito Shops of the North Pacific Coast Railroad. The first American cab-forward locomotive, this innovative design was the precursor of the modern railroad engine. "The Freak" was the second of two locomotives built in Sausalito by the North Pacific Coast. The first, No. 20, was a conventional design built in 1900. (Courtesy Northwestern Pacific Railroad Historical Society.)

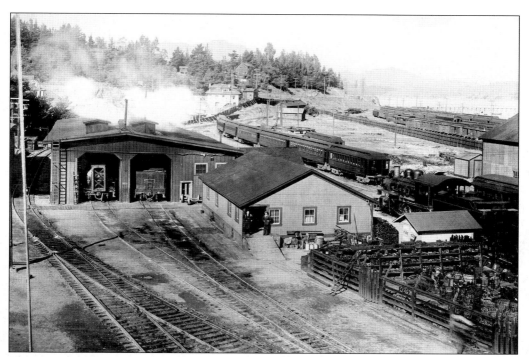

The Sausalito Shops and rail yards of the Northwestern Pacific Railroad were located at Pine Point near the foot of Spring Street, where the Army Corps of Engineers' San Francisco Bay Model is found today. In 1942, they were dismantled when construction of Marinship, a massive World War II shipbuilding facility, was begun.

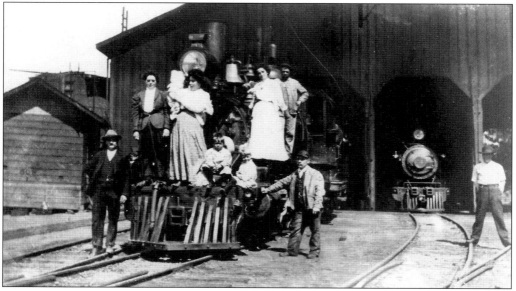

Many Sausalito residents earned their living working for the Northwestern Pacific Railroad and its predecessor companies. In this photograph, a longtime rail yard worker, Frederick Perry, is shown with his family on a holiday outing in the yards in 1910. "Fritz" Perry, the little boy seated on the right of the cowcatcher, would be honored 85 years later as Sausalito's oldest lifelong resident.

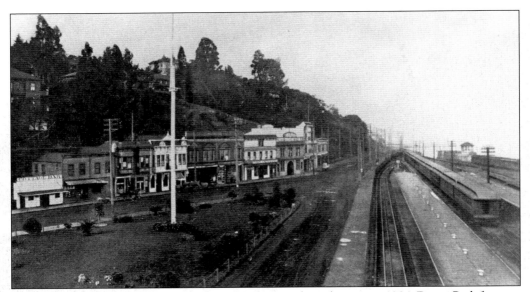

Water Street and the downtown business district are relatively quiet in 1904. Depot Park features a ship's mast as a flagpole, having not yet received the fountain and elephant statues which would come to it from the San Francisco Panama-Pacific Exhibition of 1915. The automobile has not yet made a significant impact on the streets of Sausalito.

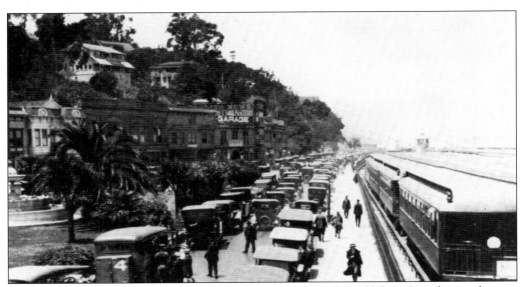

By the early 1920s, traffic jams have become an unpleasant fact of life in Sausalito as the new auto ferries encourage San Francisco motorists to bring their cars across the bay.

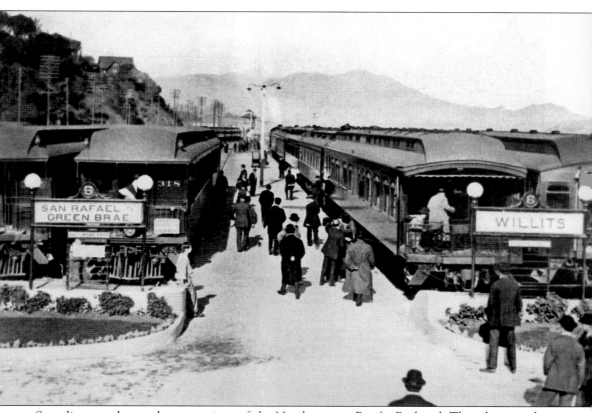

Sausalito was the southern terminus of the Northwestern Pacific Railroad. This photograph, taken in October 1914, shows passengers preparing to board a special train, the "Spiker's Special," to Willits. The train then continued on to Cain Rock, where the railroad would drive a golden spike to complete the connection to the track from Eureka. (Courtesy Northwestern Pacific Railroad Historical Society.)

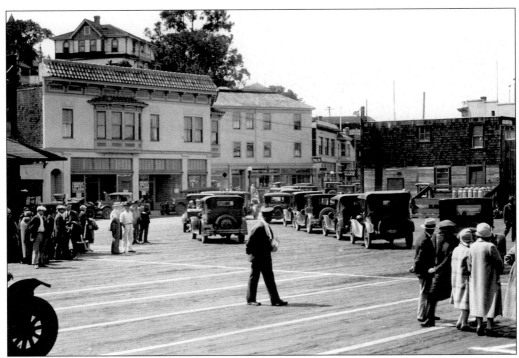

In 1922, the Golden Gate Ferry Company began automobile ferry service between San Francisco and Sausalito, using the site of the town's original ferry landing at the foot of Princess Street. The wooden platform, which provided automobile access to the ferryboats, was later dismantled and today Yee Tok Chee Park, named for the beloved proprietor of the Marin Fruit Company, occupies the site pictured above.

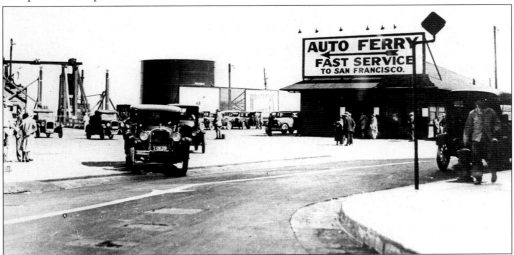

The new auto ferry service, which began with one boat in 1922, proved so successful that two more boats were soon added to the Golden Gate Ferry fleet and operated around the clock. Threatened by the loss of its transbay monopoly, the Northwestern Pacific Railroad was forced to order its own auto ferries and soon engaged in fierce competition for the rapidly increasing automobile business.

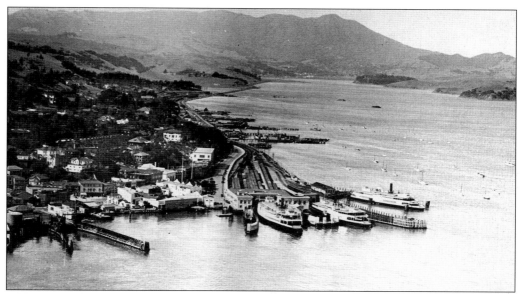

This bird's-eye view of the Sausalito rail and ferry terminal dates from 1925. In the slips are the *Eureka,* the *Sausalito,* and the *Cazadero.* The Golden Gate Ferry terminal, located at the foot of Princess Street and dedicated to automobile ferry service, is also visible at the extreme left.

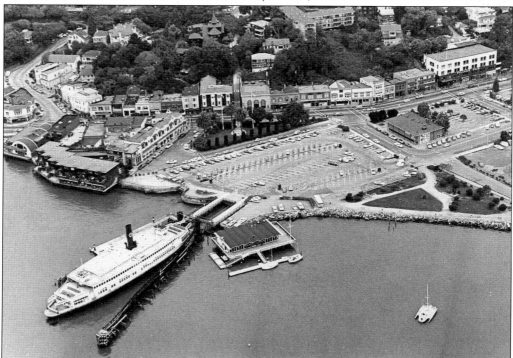

By 1972, when this photograph was taken, the railroad tracks and terminal that formerly dominated Sausalito's downtown were long gone, having been replaced by a parking lot. At the pier lies the *Berkeley,* built as a ferry in 1898, but tied up in Sausalito from 1960 to 1973 as the Trade Fair, a retail emporium. She was then sold to the San Diego Maritime Museum, where she may be seen today.

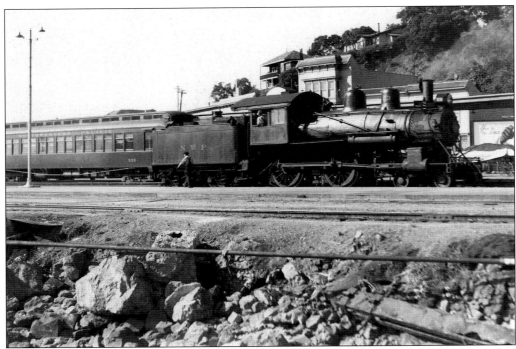

Northwestern Pacific Engine No. 23, built in 1908, is seen here in 1940 backing into the Sausalito Depot to take Train No. 2 on the day run north to Eureka. The 278-mile journey to the end of the line was scheduled for 11 hours and 20 minutes.

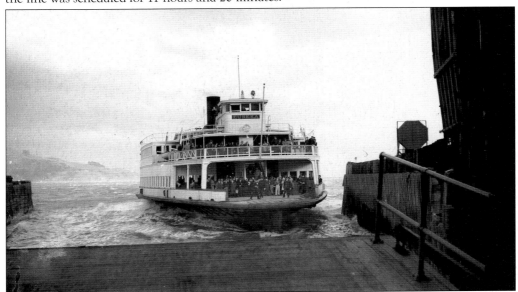

The *Eureka* was originally built as the rail car ferry *Ukiah* in 1890. She was rebuilt as an automobile ferry in 1922, and operated by the Northwestern Pacific Railroad on the San Francisco-to-Sausalito run. The largest passenger ferry in the world, she was the last of the walking-beam and paddle-wheel ferries that had traversed the bay for more than 65 years. She may be seen today at the San Francisco Maritime Museum.

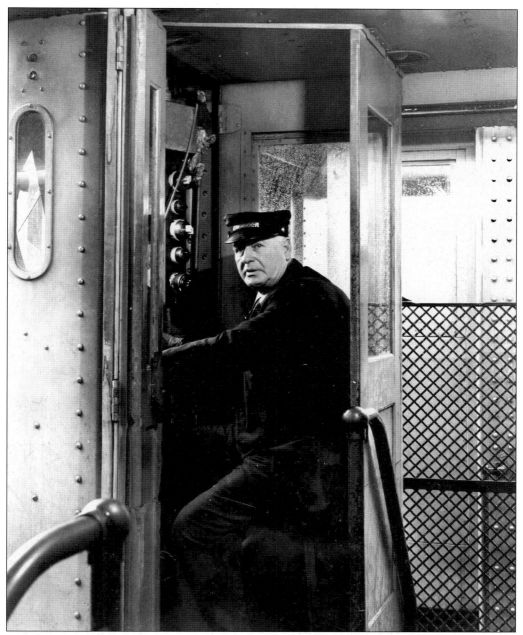

Hired by the North Pacific Coast Railroad as a fireman in 1896, Will Ritchie was promoted to engineer in 1899 and continued to serve on the North Shore Railroad and its successor, the Northwestern Pacific, for 45 years. He is shown here in 1941 in the motorman's compartment of an electric train, while at the Sausalito Depot. Only weeks after this photograph was taken, all passenger train service to Sausalito was eliminated.

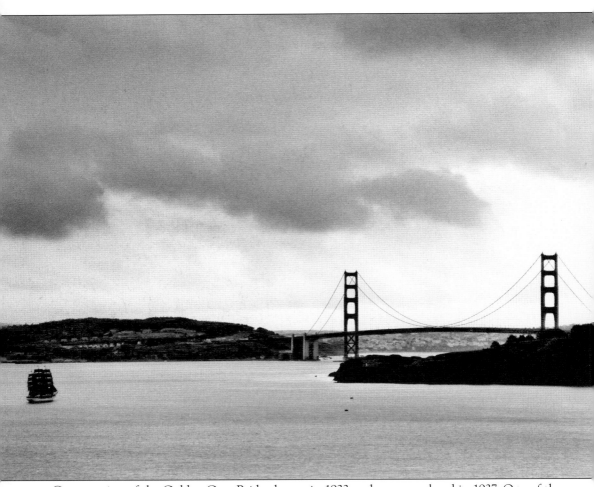

Construction of the Golden Gate Bridge began in 1933 and was completed in 1937. One of the engineering and architectural marvels of the 20th century, the bridge brought an end to the need for automobile ferry service to Sausalito, and led to the demise of Sausalito's passenger rail service. In just a few years, the town's identity as a great railroad terminus was only a memory.

Four

TO THE BAY IN BOATS

BY CHARTER KAYS

Sausalito by Sutton Wood.

The history of Sausalito's boatyards, yacht clubs, and sailing activities begins with the initial use of Shelter Cove (Old Town) by immigrant fishermen, who hauled their lateen-rigged, double-ended feluccas to the beach, or onto simple skidways for hull maintenance and rigging repairs. In fact, Sausalito's boatbuilding culture developed and thrived in the late 19th century largely because of an influx of new arrivals from southern Europe.

In the late 1800s, early boat builders such as G. Smith, Brixen and Manfrey, and California Launch Building Company built boatyards along the beach at Valley, Main, and Richardson Streets. Later boatbuilding operations came and went or burned down. But by the 1920s, two prominent yards were flourishing. The Reliance Boat Company was busy building boats and devising new ways of handling them, as were Manuel and Antonio Nunes, Portuguese immigrants from the Azores who had arrived in Sausalito by way of the Sacramento River.

Concurrent with developments in Shelter Cove, Stephen Bregante, a first-generation Italian American, set up a simple skidway to haul and launch boats in New Town at the foot of Napa Street.

Bregante specialized in fishing boats, particularly feluccas, which were fast, slender sailing vessels chiefly from the Mediterranean. Bregante's operation, the Atlantic Boatbuilding Plant, was later replaced by Crichton and Arques (1914–1916), Sausalito Shipbuilding, and Bob's Boatyard.

Another Italian immigrant, Menotti Pasquinucci, located his boatyard at the foot of Turney Street in New Town, building and maintaining fishing boats, workboats, and occasionally, yachts. Menotti's son Frank eventually took over and operated the boat shop until the mid-1950s.

In 1915, J. Herbert Madden, of Irish descent and formerly a shipwright at Anderson and Cristofani Shipyard, purchased a section of waterfront property between Turney and Locust Streets from Menotti Pasquinucci. He established Madden & Lewis Shipyard, which along with Nunes Brothers, not only built and repaired fishboats, workboats, yachts, and government-contract vessels in quantity for decades. Both yards lasted into the 1950s. Madden & Lewis finally closed in 1960.

Since World War II, several of these small yards have offered limited boat construction, repair, and yard time to boat owners, many from local yacht clubs. The best known are, or were, Spaulding Boatworks, Bob's Boatyard, Easom Boatworks, Sausalito Marine, Bayside Boatworks, Richardson Bay Boat, the Boatbuilders Co-op, and Anderson's Boat Yard.

Yacht clubs have patronized Sausalito boatbuilders since the San Francisco Yacht Club moved to Water Street in 1878. From the beginning, they commissioned local boatbuilders and yards to build one-design, specification sailboats to various racing standards, dinghies for youth and junior sailing programs, and cruising vessels for club members. Most builders offered railways for hauling out boats for repairs, maintenance, and painting.

Boatbuilders such as J. H. Madden Sr., Myron Spaulding, and Hank Easom became actively involved in club racing as builders, skippers, designers, and measurers of both bay and ocean racing vessels. Boats would be measured for conformity to rules governing waterline length, overall length, float marks, sail area, rig variations, and legal ballasting, among other things. Boats with a current legal measurement certificate were cleared to race; non-conforming craft might require a brief haulout at the local boatyard.

The San Francisco Yacht Club was not the only club to choose Sausalito as its permanent home. A splinter group of the wealthy boat owners who had started the club near San Francisco's Mission Bay disagreed with the majority's selection of Sausalito's Water Street as their new, permanent building site. So they formed their own club, the Pacific Yacht Club, and located it at Shelter Cove.

In 1899, the Pacific folded and sold its property to the Spreckels family for a summer house. The original San Francisco Yacht Club burned in 1897, and in 1898 was replaced by a new club which still stands, as the Horizons restaurant. The club moved to Belvedere in the 1920s. Today the local yachting community is served by the Sausalito Yacht Club and the Sausalito Cruising Club.

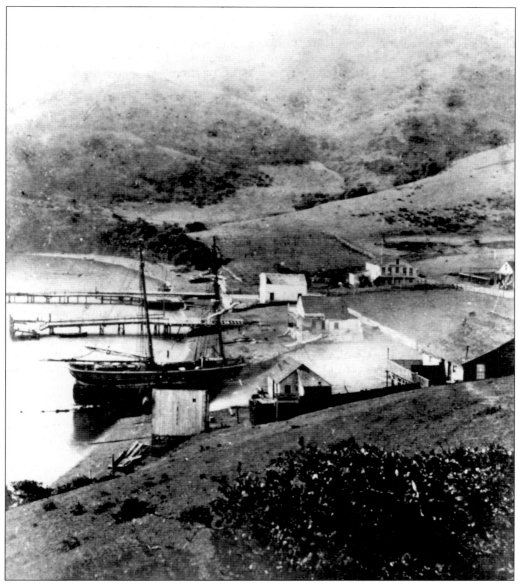

Taken about 1851, this is the earliest known photograph of Sausalito. In Old Town Sausalito—called Shelter Cove for its anchorage and Hurricane Gulch for the winds that funnel through it—a small brigantine is hauled out on a skidway for planking repairs to her starboard topsides. Two men working on a raft at water's edge, immediately to the left of the shed, are hanging planks prior to securing them to the frames. Steam from a steambox is seen to the right of the shed. Planks are placed in a long, rectangular, wooden box, pumped full of steam to soften them so they can be bent to the hull of the ship. The first pier beyond the ship is approximately where the *Walhalla* was built in 1893. The far pier is approximately where Nunes Brothers Boat and Ways Company would locate in the 1920s. (Courtesy Sausalito Woman's Club.)

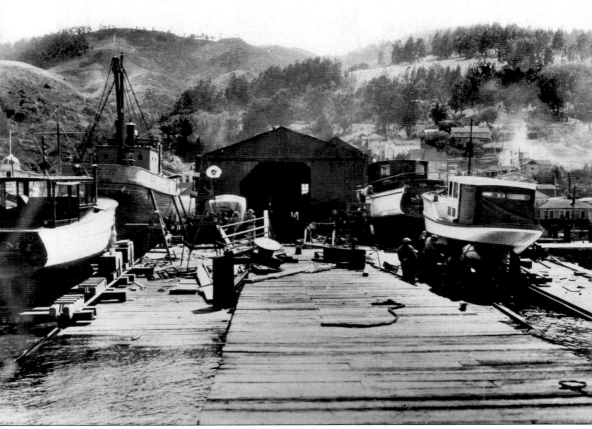

The Nunes brothers, Antonio and Manuel, were born in the Azores. Manuel, a former fisherman turned shipwright, came to the United States first and began his boat shop in 1898, working from a barge on the Sacramento River. Antonio arrived in Sacramento in 1905 and went into partnership with his brother. From this barge boat shop, the Nunes brothers built fishing boats, hay barges, sailboats, small tugs, and later on, speed boats. In the 1920s, the brothers settled permanently in Sausalito at the foot of Main Street near Second Street. They named their venture Nunes Brothers Boat and Ways Company, shown here in a late-1920s photograph, taken shortly after the move. From the left is the cruiser *Mimi*, a fishing boat belonging to the Paladini family from Fisherman's Wharf in San Francisco, assorted staging horses, onlookers, and the yard crew, painting the topsides on a cruiser and the bottom on a launch, while the foreman looks on.

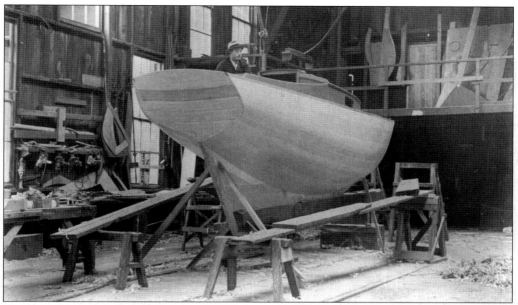

Tony Nunes is at work in the cockpit of a classic Bear boat, a number of which still sail on San Francisco Bay. In 1957, Nunes Brothers launched its last Bear, No. 60. In the loft behind the Bear are molds. A cluttered work bench runs along the wall to the left, and power tools hang above. Typically the interior of the shop is unpainted, as boatyards operated frugally and paint wasn't wasted indoors.

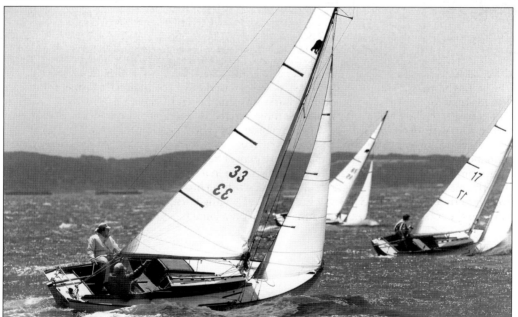

Three Bear sloops are close hauled in a freshening westerly. By the mid-1950s, the Bears were the largest one-design fleet on San Francisco Bay, with a competitive peak in the 1960s. In all, 69 Bear boats were built. Construction peaked in the 1950s, and the last boat was built in 1976. (Courtesy San Francisco Yacht Club.)

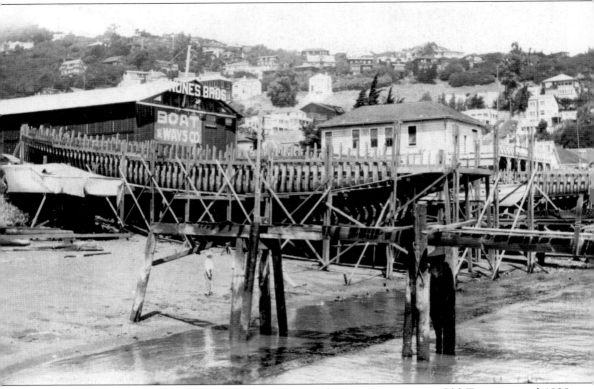

Under construction at Nunes Brothers Boat and Ways Company in Old Town around 1928 were two large fishing trawlers, the *Funchal* and the *Greyhound*, both of double-sawn frame construction. These vessels would be used in the tuna-fishing industry. Note the close spacing of the frames—these are stoutly built craft. The person on the beach between the pilings of the foreground pier adds a sense of scale to the scene.

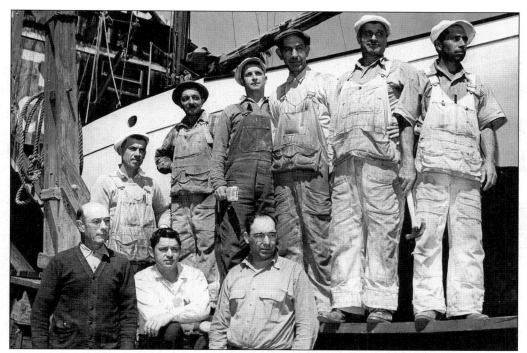

The Nunes Brothers crew posed in front of big Bird *Mary Beth* on a sunny, post-World War II day. Pictured, from left to right, are (first row) Tony Nunes, an unknown man, and Ernest Nunes; (second row) unidentified, Joe Amarl, Manuel Silva, Frank Sarmento, Mario Beviagua, and Joe Rodriquez. Note the standard boatyard garb of caps, multi-pocketed overalls laden with fasteners, small tools, pencils, and bevels.

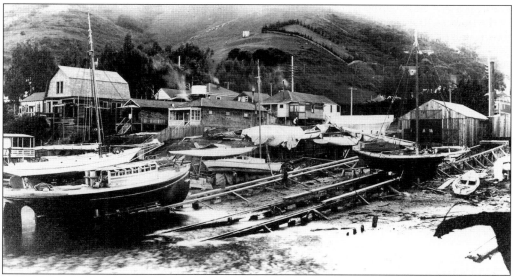

This photograph, taken about 1920, shows Reliance Boat and Ways Company in Old Town with a variety of craft hauled out on three ways—sloops, a steam or gasoline launch (left), boats under tarps, and at far left, an ark. On the hills behind, a pasture has been laid out and trees planted as a wind break on the otherwise treeless terrain.

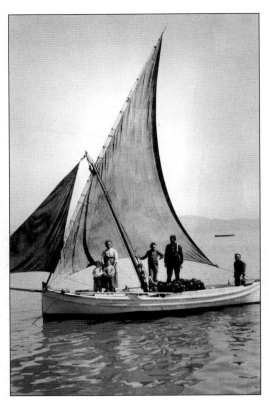

The Bregante family poses aboard a felucca for a formal portrait, probably in the late 1880s. Nicola (Stephen) Bregante is in the stern. The felucca, a Mediterranean-type fishing craft of lateen rig, much favored by southern Italian fishermen, was modified to suit the San Francisco waters by shortening its rig. But fishermen continued to use the traditional cork-floated *paranzella* nets. The Monterey fishboat evolved from the felucca.

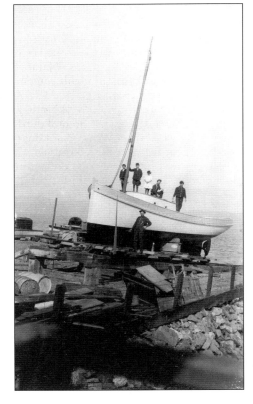

In about 1900, a proud Stephen Bregante (in front, wearing hat) poses with others on a fine little auxiliary sloop. The sloop sits on a sliding carriage and is prevented from falling over by the support chocks amidships. Note the use of riprap as fill to provide a firm foundation and to reduce erosion around the ways.

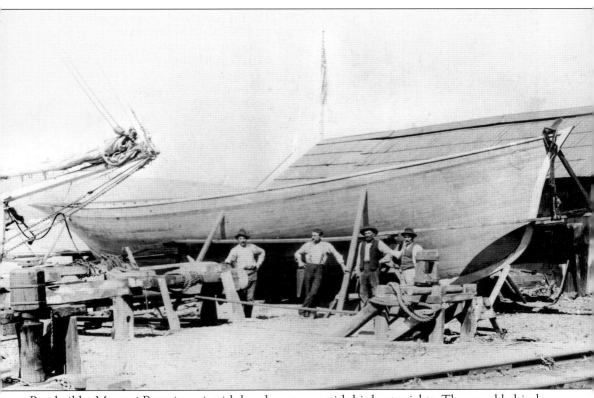

Boatbuilder Menotti Pasquinucci, with handsaw, poses with his boatwrights. The vessel behind the men is newly built, whereas the vessel to the left is hauled out on the skidway for repairs. Yards such as Stephen Bregante's Atlantic Boatbuilding Plant and Menotti Pasquinucci's used the simplest and most basic yard-built equipment, as can be seen in the two, heavy, wood-timbered capstans (winches) to the right and left of the men. The heavy line leads from the skid the boat rests on, down and through the skidway, and up the beach to the lower capstan drum. Three or more turns (wraps) are taken around the drum, and the bitter end is led back towards the skidway and tailed (held) by a man who maintains tension in the line to prevent slippage around the drum. A capstan bar is then inserted through the slot in the iron-banded upper drum, at which point all hands heave around and slowly haul the boat up the ways to the near end. Some boatyards used horses for motive power instead of manual capstans.

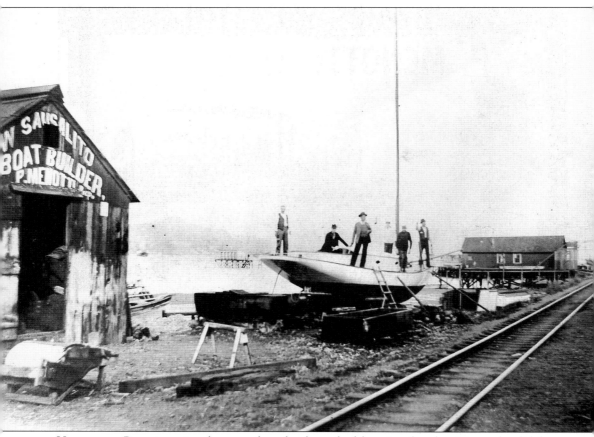

Here we see Pasquinucci and a crew aboard a sloop, freshly painted and waiting to be slid down the ways and set afloat again. Various bits of boatyard gear adorn the landscape. A bending form, sawhorse, soaking tank, and two iron tanks are set about. The sloop is set athwart (crosswise) the ways to clear the passing trains, yet high enough from the water for her keel to be painted. With her tall rig and relatively shallow draft, she may carry a centerboard. Ray Bottarini, who later became a boatbuilder himself and worked at Madden & Lewis, said, "I remember when I was a kid, how they would have to time the use of the bandsaw with the coming and going of trains every half hour, or else you'd find yourself standing in the path of an oncoming train with a huge beam in your hand."

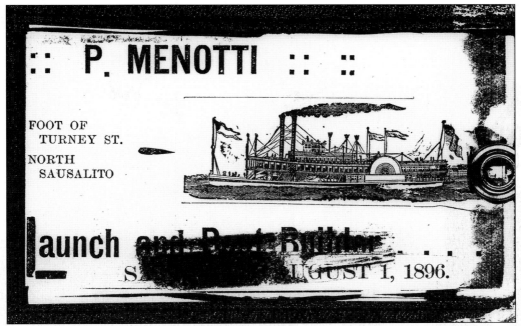

This Menotti Pasquinucci advertisement is from the August 1, 1896, edition of the *Sausalito News*. Evidently, when Menotti Pasquinucci first came to Sausalito from Italy, locals called him "Mr. Menotti," instead of "Mr. Pasquinucci." Adopting his now-familiar name, he called his boat shop "P. Menotti," and used his names interchangeably. His son Frank was always known as Frank Pasquinucci.

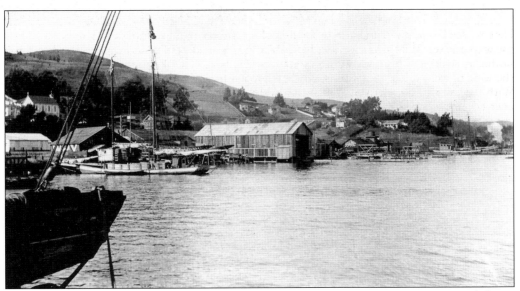

The Pasquinucci boat shop, *c.* 1900, is flanked by interesting waterfront activities. At left is a heavily laden scow schooner, her foregaff and boom hoisted to clear the unloading of her cargo. At far right, steam issues from a train, reminding us that the railroad tracks passing Pasquinucci's boat shop and Mason's Distillery on their way downtown ran close to the water.

John Herbert Madden Sr. was born in Stockton, California, in 1889, the son of Irish immigrants. He learned the boatbuilding trade working for Anderson's Boatyard near Hunter's Point in San Francisco. In 1915, he purchased land at the foot of Napa Street and established the Madden & Lewis Boatyard. Madden & Lewis built yachts, fishboats, tugs, launches, and Navy vessels, and did repairs and haulouts. In the 1930s, Madden & Lewis began buying up the land that became the Sausalito Yacht Harbor after World War II. Throughout his career, Madden, an active racer, pursued the concept of a Pacific Coast one-design class, taking his plans to John Alden's office in Boston. Alden and Sam Crocker designed the flush-deck, 30-foot sloop that, after a reduction in rig height for bay yachtsmen, became the Bird. Madden's yard built five of the Bird class boats: *Osprey* (1921), *Curlew* (1922), *Kookaburra* (1922), *Skylark* (1927), and *Swallow* (1947).

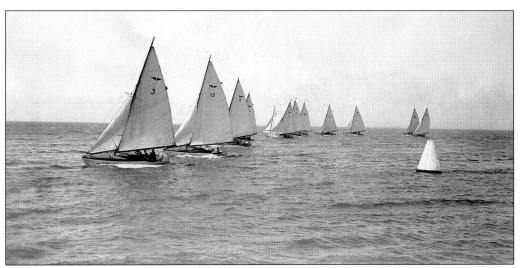

"Nothing sails like a Bird," is the proud boast of the San Francisco Boat Association. This photograph, taken at the St. Francis Yacht Club Regatta of May 25, 1933, shows *Kookaburra* (3), *Loon* (13), *Oriole* (11), *Polly* (19), and others beating to weather off the city front. Some Birds have tacked, betting on more breeze farther out to overcome the difficulty of sailing into a flood tide. Today the Bird fleet continues its unbroken record of racing. (Courtesy San Francisco Maritime Park.)

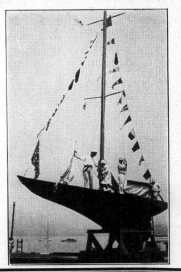
Although fishboats and tugboats were the core of its business, Madden & Lewis also built and maintained many yachts. Additionally they offered quick haulouts via their 20-ton boat crane, as can be seen in this February, 1931, advertisement from *Yachtsman* magazine.

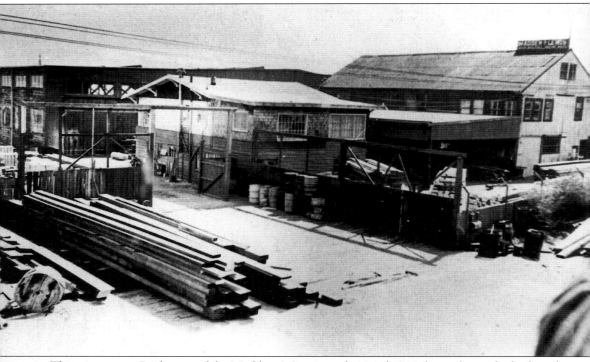

This view across Bridgeway of the Madden & Lewis yard around 1940 shows the yard rebuilt and thriving after a major fire in 1920. Stickered stacks of lumber can be seen about the many buildings of this busy yard. Madden & Lewis, along with Nunes Brothers in Old Town was the largest and longest lived of the many Sausalito boatyards. Madden & Lewis experienced a second fire 40 years later, in 1960. That time, it was too costly to justify rebuilding for the diminishing boatbuilding trade, and Madden concentrated on development of his Sausalito Yacht Harbor with the help of his son Herb Madden Jr. and a small crew of stalwarts. (Courtesy Herb Madden Jr.)

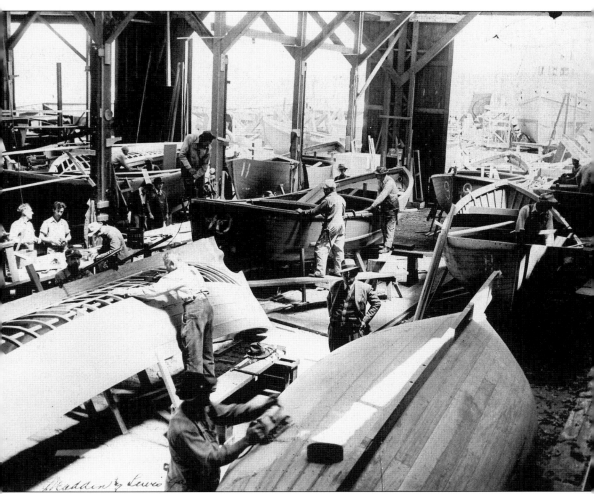

In this World War II photograph, the Madden & Lewis crew is working on a Navy contract for motor whaleboats. The boatwright standing on the staging plank, working on the inverted whaleboat planking, is Menotti Pasquinucci, who had originally sold J. H. Madden the land on which the Madden & Lewis yard was built. Apparently Menotti, operator of a boatyard next door, has come over to help with the war effort. From Sacramento and Stockton to Alviso in the South Bay, wooden boatyards in the 1940s contracted with the government to build vessels of all sizes, from gigs and whaleboats to minesweepers and tugs. Menotti's son Frank Pasquinucci continued to operate a boatyard until the mid-1950s.

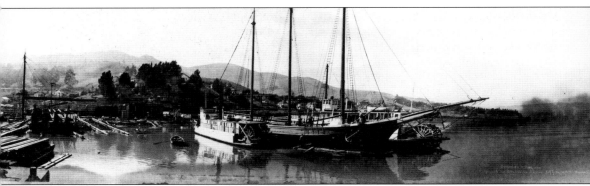

This bayside view of the Crichton-Arques shipyard (1914–1918) at the foot of Napa Street shows a variety of activities and vessels. Although Crichton-Arques leased this property from Oceanic Boatyard Company to build barges for the Sacramento River, we see here, in addition to the barge ways, two sternwheelers, *Grace Barton* on the left and *Phoenix* on the right, and a three-masted lumber schooner, the *Advance*. After Crichton-Arques closed in 1918, the foot of Napa Street was quiet for many years. In 1940, the Oakland Shipbuilding Company, originally located at the Oakland estuary, moved to the old Crichton-Arques property to build barges for the Army. Bob Rich purchased Oakland Shipbuilding during World War II, enlarged the yard, and renamed it Sausalito Shipbuilding Company, specializing in commercial fishboats. Rich sold the property in the 1960s. It went through various owners, eventually becoming the Galilee Harbor Community Association. (Courtesy San Francisco Maritime Museum.)

Myron Spaulding stands alongside varnished spars hanging to dry at his Spaulding Boatworks on the northern waterfront. Spaulding was a successful racer of Star boats in the 1920s and 1930s, then switched to a Bird boat, the *Loon*. He eventually designed his own boats—the 20-foot Clipper class, the Spaulding 33 class, and others still seen about the bay today, including *Nautigal* and *Buoyant Girl*. (Courtesy Walter Van Voorhees.)

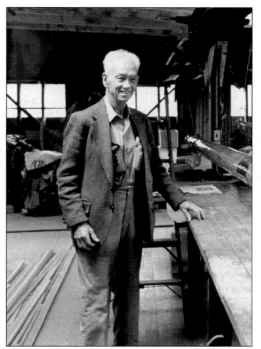

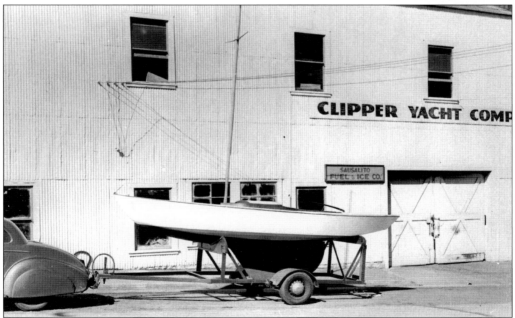

Clipper Yacht Company built 20-foot plywood Clipper boats designed by Myron Spaulding, such as the one seen here on the trailer. Clipper Yacht Company, now defunct, was located on the second floor of the Sausalito Fuel and Ice Company on Caledonia Street. Cliff Petersen built Clippers there until World War II, later joined by partner Shirley Morgan. In 1967, the increasing demands of building and operating Clipper Yacht Harbor took up Petersen's time, and Easom Boatworks picked up the construction of Clippers.

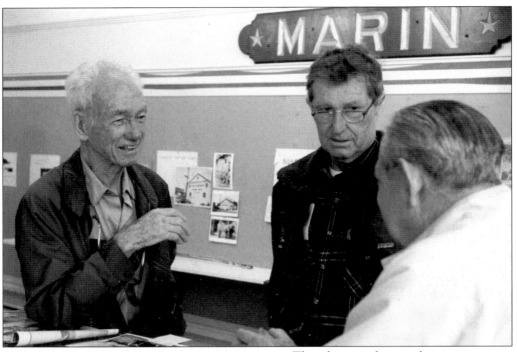

This photograph was taken at a Sausalito Historical Society boatbuilders' exhibit in 1995. Pictured, from left to right, are Myron Spaulding of Spaulding Boatworks, Hank Easom of Easom Boat Works, and Ray Botterini, who worked for Madden & Lewis. These men were major figures in Sausalito's maritime history during its heyday of commercial boat and ship building (1925–1955). Spaulding and Easom were also longtime leaders and participants in the world of yacht racing.

This 1995 photograph looks down the carriageway at Easom's Boatworks, where a great deal of work on fiberglass yachts was performed. A real change in the nature of boatyards and yachting took place during the 1950s and 1960s as more fiberglass production boats replaced older yachts built of wood. Traditional yards closed, unable to compete with the low construction and maintenance costs of production "glass" boats.

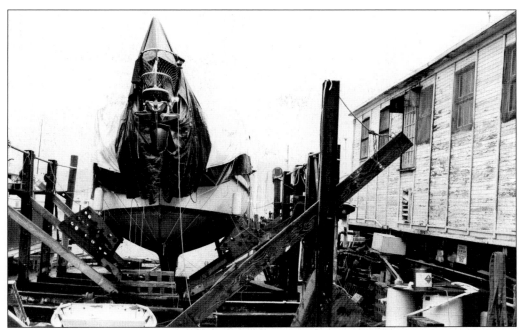

In this 1995 photograph, Ross Sommer and Dale Gough continue to haul and repair boats on their railway at Richardson Bay Boatworks in the historic Arques Shipyard. Note the perforated bearing blocks (adjustable to various hull shapes) and their adjustable diagonals in the boat carriage. The building to the right is the shop/office.

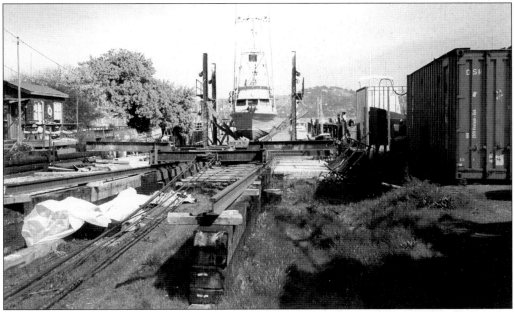

This is Bayside Boatworks, located in Arques Shipyard, adjacent to the old Marinship yard. The railway iron can be plainly seen in this 1999 photograph, along with the wooden sleepers, the hauling cable, and carriage. Note the container to the right. These have become quite popular for tool, machinery, and supplies storage. (Courtesy Paul LeClerc.)

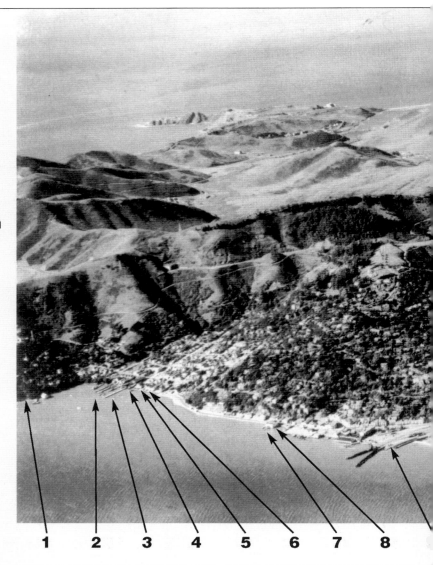

1. Pacific Yacht Club Dock
2. Nunes Bros.
3. Stone's Shipyard
4. Reliance Boat
5. California Launch Company
6. G. Smith
7. San Francisco Yacht Club
8. Lange's Launches
9. Sausalito Yacht Club
10. Sausalito Yacht Harbor
11. Clipper Yacht Company

This 1942 aerial view shows why Old Town and New Town attracted so many boatbuilders. The sheltered anchorages and gently sloping land at the shoreline on either side of downtown (at the center of the photograph) were perfect for building piers and shipways. The pilings of the Nunes Brothers' piers remain as reminders of this older maritime heritage. Today boatyards

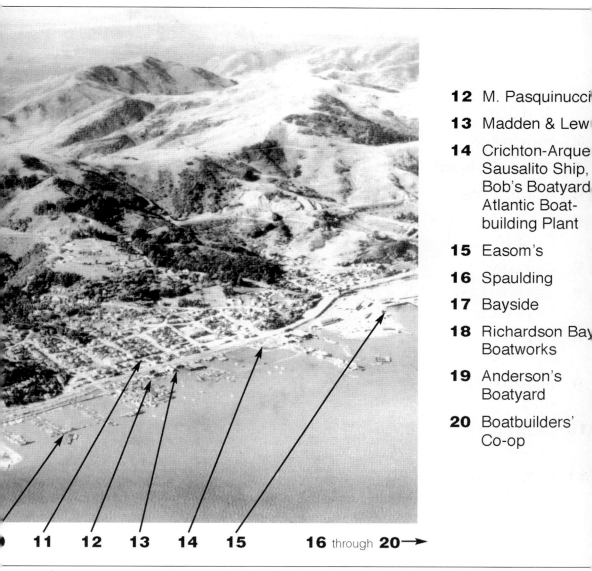

12 M. Pasquinucci

13 Madden & Lew

14 Crichton-Arque
Sausalito Ship,
Bob's Boatyard
Atlantic Boat-
building Plant

15 Easom's

16 Spaulding

17 Bayside

18 Richardson Bay
Boatworks

19 Anderson's
Boatyard

20 Boatbuilders'
Co-op

11 **12** **13** **14** **15** **16** through **20** →

and marine businesses still operate in the Marinship area, site of World War II Liberty Ship and tanker construction, and continue their historic role of providing services to those who live and work on San Francisco Bay.

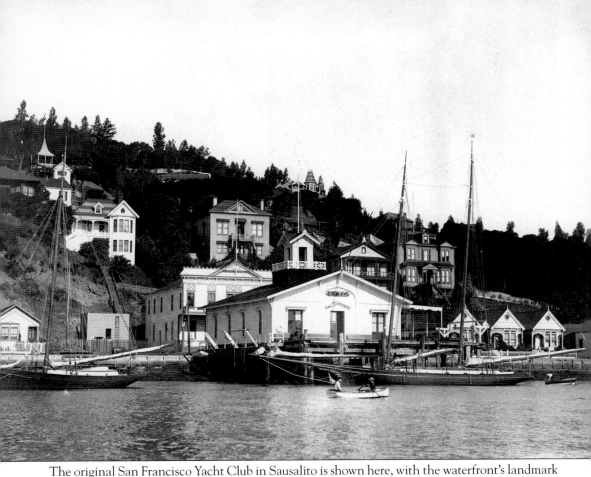

The original San Francisco Yacht Club in Sausalito is shown here, with the waterfront's landmark "Three Sisters" cottages to the right. A gaff cutter rides at anchor, a schooner yacht lies at the club wharf, and a couple of people are out for a row. The club was founded in 1869 in San Francisco, making it the oldest yacht club on the West Coast. In 1878, it moved to Sausalito. This building, destroyed by fire in 1897, was replaced the following year by a larger and much grander structure. (See photograph of the new yacht club building, completed in 1898, on page 4.) In 1927, the San Francisco Yacht Club moved to Belvedere due to increasingly scarce parking on Water Street and the disruptive wakes created by the Golden Gate Ferry Company's auto ferries as they departed from their new wharf directly to the north. (Courtesy Bancroft Library.)

A skipper in vest and top hat reaches his gaff-rigged catamaran along the Sausalito waterfront. This was truly a cutting-edge, high-speed craft for its time (late 1800s). Note the plank-type bowsprit with foot ropes, reefed mainsail, and minimal wake from the outriggers. The San Francisco Yacht Club is the white building with the bell tower on the right.

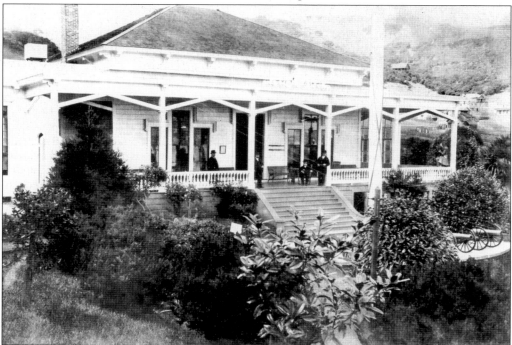

The Pacific Yacht Club was formed as a result of a divisive split within the San Francisco Yacht Club. Here we see club members relaxing on the porch, with an imposing flagpole at right center and, of course, the mandatory cannon—useful for firing salutes, starting races, and observing the Fourth of July. The Pacific Yacht Club was located at Shelter Cove from 1878 to 1899. The Spreckels brothers bought it in 1899 when the club became insolvent.

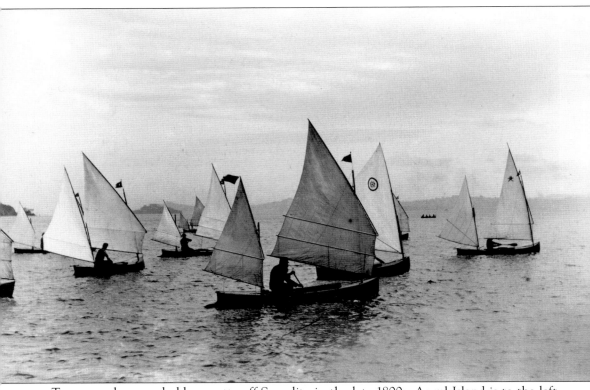

Two-masted canoes hold a regatta off Sausalito in the late 1800s. Angel Island is to the left, and Alcatraz Island is the small dark mass to left of center. The San Francisco skyline is in the distance, center to right. Note the use of oars as impromptu leeboards, the full-length sail battens, and rigging variations. Early yacht racing ranged from simple pick-up affairs or match races between boats of similar rig or size (competing perhaps for a keg of beer), to Pacific Interclub Yacht Association regattas dating back to 1896, to the Master Mariners' Annual Race. Sausalito's yacht clubs began by sponsoring invitationals, eventually coming under the umbrella of the Yacht Racing Association of San Francisco Bay, which coordinated the races of member clubs. (Courtesy Bancroft Library.)

Five

WHERE TEMPERANCE NEVER CAUGHT ON

BY PHIL FRANK

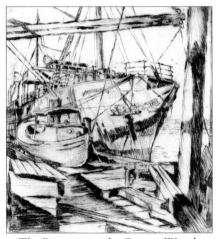

The Rumrunners by Sutton Wood.

In the 1920s and early 1930s, Sausalito became a major player in Northern California's effort to skirt the 18th Amendment, which had made it illegal to manufacture, sell, or transport intoxicating beverages in this country. On the surface, the Volstead Act, the law that implemented the 18th Amendment, was more or less observed. Beer breweries switched to soft drinks or low-alcohol "brews," or just went out of business. Liquor stores shut down. Bars became soda parlors. Hundreds of distilleries closed their doors.

But Prohibition, as it was popularly called, was doomed from the beginning. The trouble was that it took such a long time to die—from 1919 to 1933. And during that time, much of the rum- running and bootlegging action on the West Coast centered on Sausalito. The reasons were obvious. First, it was the closest harbor to the Golden Gate. Fast boats—rumrunners as they were called—could be built and serviced in the town's boatyards, moored in Richardson's Bay, and

fueled at its docks. Second, Sausalito was the jumping-off point for most North Bay ferryboats headed to San Francisco. At night, boatloads of liquor were brought to the rocky Marin County coastline in speedy boats, operating from Canadian and Mexican "mother ships" lying offshore in international waters. The cargo would be loaded onto trucks or into cars and, traveling the back roads, funneled through Sausalito to the ferry landings at Water and Princess Streets.

The town had a two-man police force generally tolerant of local "soda parlors" known to lace their lemonade with alcohol, as long as the owners weren't too flagrant about it. It was only when barrels came in the front door, or grocery stores were found open in the wee hours of the morning with their curtains drawn, that local authorities clamped down.

Federal Prohibition officers based in San Francisco were highly suspicious of the little town across the bay. They knew there was alcohol traffic, speakeasies, and stills in operation there. But the only way to get to Sausalito was on the ferryboats, and the ferry workers were mostly locals. A phone call from San Francisco to Sausalito could beat a ferryboat to its slip any day; so every time the officers arrived, an air of temperance pervaded the town.

Federal authorities were convinced that Sausalito police were in cahoots with the rumrunners, or were aiding and abetting the bootleggers. One headline from the *Sausalito News* in the 1920s read, "Prohi Officers Draw Guns On Sausalito Police." The fact that Mason's Distillery was located in Sausalito also drew the attention of the Feds. Since Mason's was a major producer of whiskey prior to the 18th Amendment, after 1919 it was allowed, under federal supervision, to continue producing alcohol for industrial and medical purposes. By 1925, it was generating two million gallons of denatured alcohol annually, nearly one-sixth of all the alcohol produced in the United States.

During Prohibition's lifespan, Sausalito hosted several speakeasies—neighborhood bars operating out of private homes—as well as unknown numbers of illegal stills back in the hills. Rowboats slipped under wharves after dark and tapped signals on waterfront restaurant floor hatches, after which "hootch" would be passed in gunny sacks into waiting hands. When the Sausalito Woman's Club was preparing for a party, a call could be placed to the Sausalito Pharmacy, and a "prescription" for five gallons of medicinal alcohol would be written.

The nation breathed a sigh of relief when the 18th Amendment was repealed, but it was a wistful breath in Sausalito. Here there was a hint of regret that the income flowing from Prohibition, the excitement it offered, and its opportunities for enjoying forbidden pleasure, was a thing of the past.

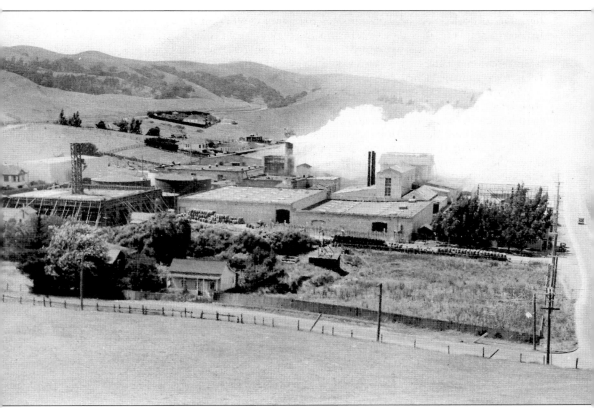

Mason's Distillery, located in north Sausalito on the site occupied today by Whiskey Springs, had been a major manufacturer of alcohol since it was founded in 1892. After the 18th Amendment was passed, the distillery switched over to "medicinal" alcohol (under federal supervision), and produced one-sixth of the alcohol in the entire nation. The distillery was destroyed by a major fire in the late 1960s.

Manuel Menotti, constable and traffic officer, was a longtime member of the Sausalito police force in the 1920s and 1930s. Widely respected, he took part in the identification and capture of John Paul Chase, a local boy who became right-hand man to nationally known Chicago gangster "Baby Face Nelson," who operated out of Sausalito in the early 1930s. For his association with Nelson, Chase spent 26 years on Alcatraz, the longest term that any prisoner spent there.

Federal Prohibition officers, known as "Prohis," are seen here with a batch of confiscated booze. These officers were continually frustrated in their attempted raids on Sausalito speakeasies and stills because, in the time it took to make the ferryboat crossing from San Francisco, ferry crew members, mostly Sausalito residents, could make a simple phone call. In that half-hour, any "establishment" in jeopardy could easily get rid of the evidence.

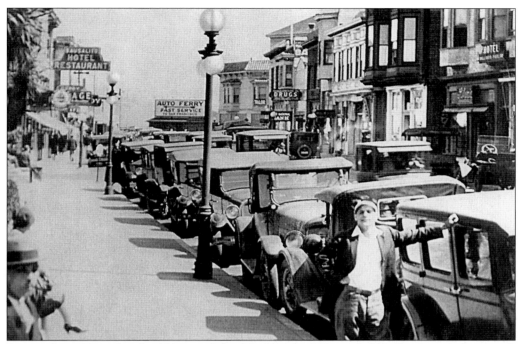

During the 1920s and early 1930s, any federal Prohibition officer would be hard-pressed to search the volume of traffic flowing in and out of Sausalito on any given day. Two ferry systems were operating at the same time, with boats leaving every 20 minutes. On weekends, traffic would sometimes back up two miles north of town as cars waited to board ferries to San Francisco.

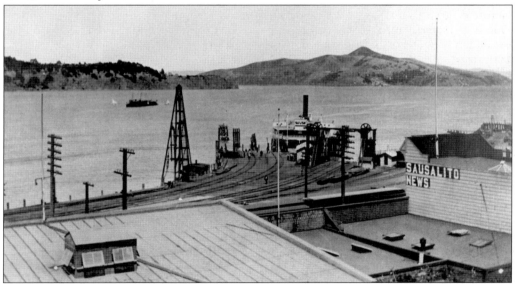

Sausalito played a pivotal role in rum-running and bootlegging during the 14 years that Prohibition was the law of the land. This view of bay, ferry, and vehicle access explains the town's importance. Access to San Francisco from the north was primarily via Northwestern Pacific ferries out of Sausalito. Most liquor entering the Bay Area came ashore on West Marin beaches, then to Sausalito, and ultimately San Francisco on tarpaulin-draped trucks.

1927

This innocent-looking carriage house on Spring Street served as one of the infamous speakeasies that flourished in Sausalito during Prohibition. It was owned and operated by Jack Witsch, who lived with his family next door. A speakeasy was a neighborhood bar operated out of a basement, back room, or in this case, a carriage house. Liquor was served to known clients who had to identify themselves at a locked door before they could enter. Card games and slot machines were provided for entertainment.

Dollie Witsch Langhoff recalled in 1996, "I don't remember much about the speakeasy, but I remember stories that 'Pretty Boy Floyd' and 'Babyface Nelson' were there and . . . that dad had twice sold some liquor to Al Capone. Grandpap Jacob Witsch would sweep the speakeasy every day. He'd have a little nip between jobs. Billy Cochrane, pictured here with my brother in about 1927, took care of the slot machines."

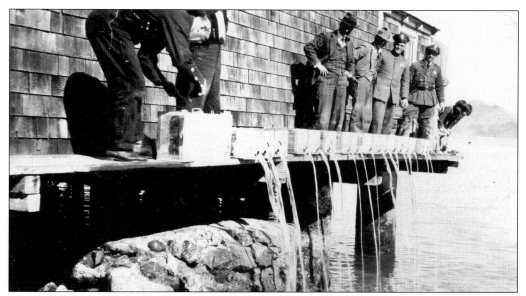

This photograph is one of the most famous local images associated with Prohibition. In it, fire chief Charley Loriano, police chief James McGowan, and traffic officer Manuel Menotti supervise while confiscated contraband is poured into the bay as two local kids watch. The story passed down through the years holds that the scene was staged for publicity and only water, not alcohol, was dumped.

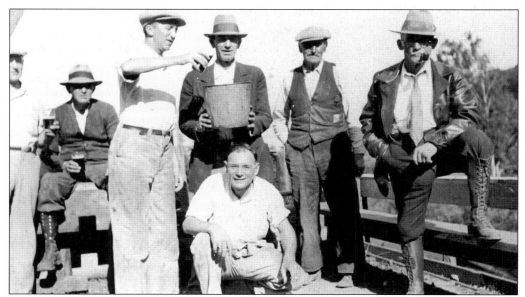

This group of locals outside a Sausalito speakeasy gives a half-hearted salute to the demise of Prohibition in 1933. The repeal of the 18th Amendment would be a mixed blessing. While distilled spirits would once again be available, the adventure and easy money related to rum-running and bootlegging was over for good.

This captured rumrunner, tied up alongside its captor, a Coast Guard pursuit craft, is one of the fast, twin-engine vessels that regularly headed out for late-night meetings with Canadian or Mexican mother ships. Sitting outside the three-mile limit, they were able to sell distilled spirits to all comers. The liquor would be loaded onto the rumrunners, which would speed toward the Marin shore and drop off their shipment to waiting rowboats. They, in turn, would load the goods onto trucks for transport through Sausalito.

This rare nighttime image shows the Canadian mother ship *Quadra*, a former yacht laden with illegal liquor, that was captured by Coast Guard boats and brought into Sausalito, as seen here. Its seizure became an international incident between Canada and the United States. The ship languished in Sausalito for years while legal arguments flew back and forth.

Six

WORLD WAR II
93 SHIPS IN 1,311 DAYS

BY CARL NOLTE

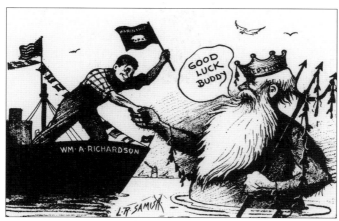

Marin-er, October 16, 1942 by L. R. Samish.

The attack on Pearl Harbor on December 7, 1941, shook the world. On March 2, 1942, Adm. Emery S. Land, head of the U.S. Maritime Commission, sent a telegram to the headquarters of the W. A. Bechtel Corporation in San Francisco asking whether the company would be interested in building a new shipyard on the West Coast. Bechtel had a site in mind—the northern Sausalito waterfront. It had deep water and a rail connection. Bechtel wired back the answer: Yes.

Ten days later, on March 12, 1942, Bechtel signed a contract to build and operate a shipyard and deliver 34 ships by the end of 1943. There was no such thing as a feasibility study or an environmental impact report in those days. Never mind that some families lived on Pine Hill, which Bechtel proposed to demolish. They had to move—this was war.

Within six weeks, crews had torn down Pine Hill and used it to fill part of Richardson's Bay, dredged a deepwater channel, relocated a rail line and a highway, and started work on 21 buildings,

two outfitting docks, and a new rail network. They called it Marinship. By June 27, the keel of the first ship was laid. By September that same year it was launched, and by the end of the year it had sailed out the Golden Gate, bound for Australia. It was named the *William A. Richardson* in honor of the founder of Sausalito.

To staff the yard, the government hired 20,000 workers. To house them, it built its own town, Marin City, just north of Sausalito. Marin City was planned in three days, and built in weeks. By the end of 1943, it was the second largest town in Marin County.

Most of the new shipyard workers had been recruited from other parts of the country, many coming from the South. Many were African American—in an area where the prewar black population of San Francisco was only 4,846 out of an overall population of over 600,000. More than a third of the new hires were women, which was previously unheard of. Only 10 percent had any training in shipyard work. Many had never seen a ship. They had to be trained.

Suddenly quiet little Sausalito turned into a shipyard town, running 24 hours a day, every day of the year, lit up at night like a city. Marinship turned in an impressive performance, eventually building 93 ships. First were the simpler Liberty Ships, mass-produced, humble cargo ships that carried the sinews of war to the Pacific and Atlantic. They were not romantic craft; Marinship never built a submarine or destroyer. Marinship vessels did the dirty work, sailing as they did from Nowhere to Tedium and back, manned by civilian crews. A Liberty Ship could carry guns, cargo, jeeps, and ammunition, enough cargo to fill a railroad train nearly three miles long. Later the yard switched to building tankers to carry fuel oil across the oceans. At its peak, the yard was building 34 ships at a time, and turning out a ship a week.

The war ended on September 1, 1945, and not long afterward, Marinship was shut down. There was some talk that it might stay in business as a ship-repair facility, but that was not to be.

Marinship was one of 30 shipyards scattered around the San Francisco Bay area. Collectively, they built 1,000 ships in three years. Marinship was neither the biggest, nor the most famous, but it permanently influenced life in Sausalito. Many of the buildings are still there, including the warehouse that houses the Army Corps of Engineers, the Marinship museum, and the Bay Model. The Sausalito Art Festival is held every year in the heart of the Marinship. And they say on quiet winter's nights you can sometimes see the flicker of the blue welding torches against the dark sky, but only if you use your imagination.

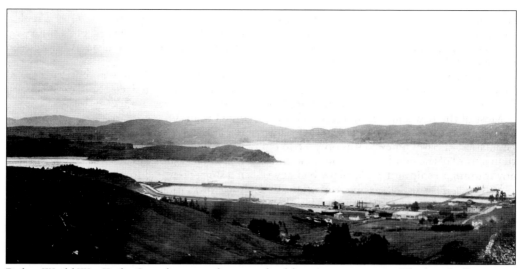

Before World War II, the Sausalito waterfront north of downtown was quiet. The bay shallows were nearly dry at low tide. It was a salt marsh full of wildlife, crossed by the double-track Northwestern Pacific Railroad, which ran freight and steam passenger trains and over 100 electric-powered interurban trains, in and out of town every day. This photograph, taken about 1922, shows the railroad tracks, the road, and the salt marsh lagoon.

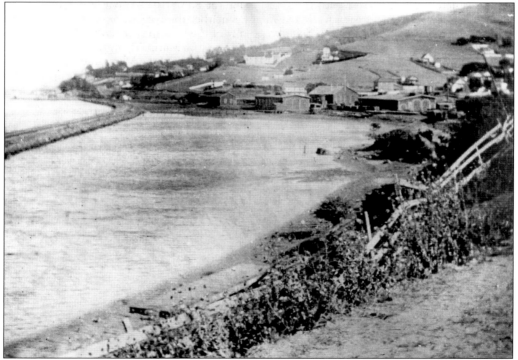

This cove was part of a saltwater marsh later filled in for wartime shipyard purposes. The fill consisted of earth blasted from Pine Hill, shown in the background of this pre-World War II photograph. The buildings in the center are part of the Northwestern Pacific Railroad's maintenance shops and sheds, where passenger cars were maintained and repaired.

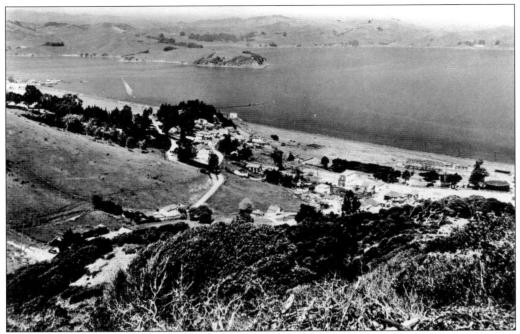

This is how the site of the future shipyard looked at the end of March 1942, just before construction began. The little wooded hill at the center of the picture is Pine Hill, site of a small neighborhood of houses. To build Marinship, the property on Pine Hill was taken by eminent domain. Houses were either demolished or moved, and Pine Hill was leveled and used as fill for the Marinship project.

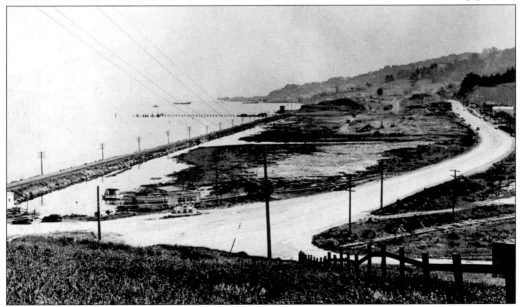

On April 15, 1942, about five weeks after this photograph was taken, Pine Hill was leveled and the lagoon filled in. The W. A. Bechtel Company of San Francisco, which had been awarded the government contract to build Marinship, was poised to begin construction. Shown here are the road into town, the railroad trestle, and some retired sailing vessels in the background.

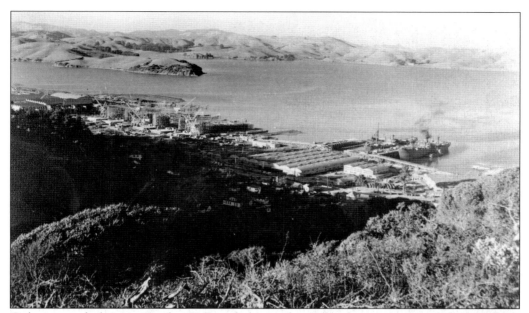

Only six months later, in October 1942, a whole new shipyard had sprung up—never had anything happened so fast in Marin County before or since. The highway was relocated, the marsh filled in, and the north Bay's biggest industrial plant was in place.

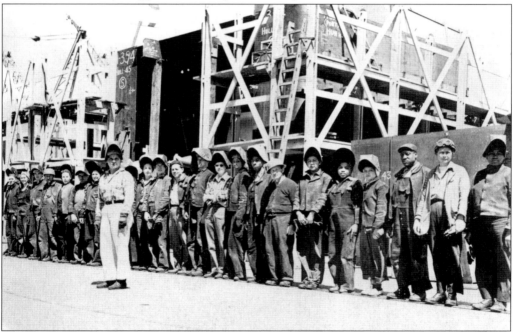

Marinship welders line up in their masks and work clothes. Notice the diversity in the lineup. Before the war, shipyard work was an all-male occupation. In the East, one shipyard owner bragged that a woman had never even been allowed inside. The welding crew foreman in this 1944 photograph is Kay Daws, a former buyer for a fashionable women's clothing store. At the time, Daws was the only woman in the United States heading up a welding crew.

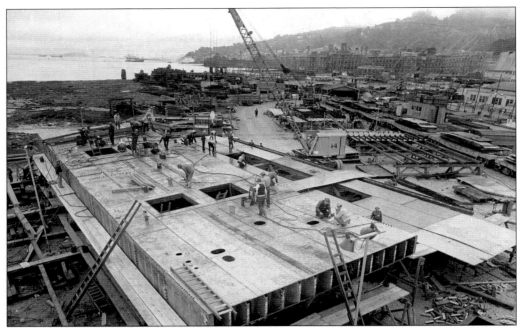

The workers here are assembling part of a ship. The key to World War II's record-setting shipbuilding effort was assembly line operations. Marinship, like other yards, put ships together from preassembled parts, the way automobiles were built. "We are more nearly approximating the automobile industry than anything else," said Adm. Emery S. Land, of the U.S. Maritime Commission.

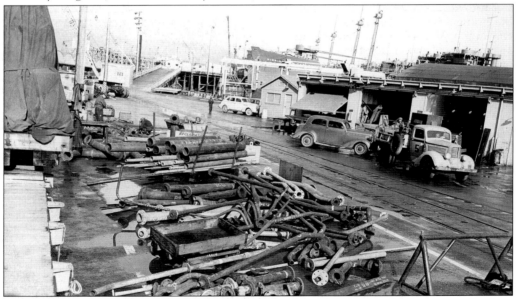

This 1944 photograph shows the clutter typical of a working shipbuilding facility—parts for ships (mostly piping here), parked cars, and ships in various stages of construction. Behind the sheds in the foreground are four Mission tankers under construction. Seen here, from left to right, are the *Mission Santa Ynez* (hull 32); *Mission San Luis Rey* (hull 35); *Mission San Rafael* (hull 73); and *Mission San Carlos* (hull 36).

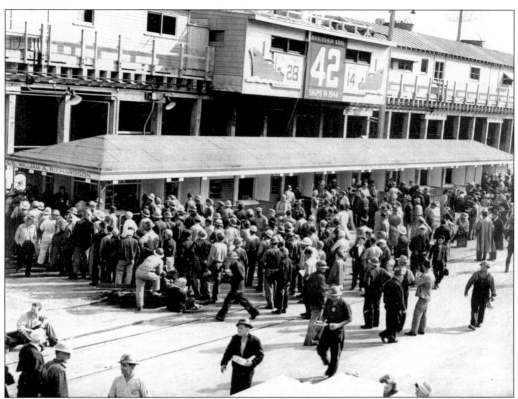

Marinship was by far the largest employer in Marin County, representing an amazing collection of wartime workers. One of 30 shipyards operating in the Bay Area, its work force at war's height climbed to 20,000 people. At its peak, the wartime shipbuilding industry around San Francisco Bay employed 244,000 workers. As this photograph shows, Marinship's goal for 1944 was 42 ships. On this day, we see 28 have been delivered, with 14 ships to go.

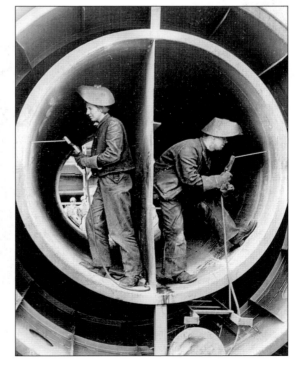

Here welders work inside the innards of a brand new ship. Marinship not only employed people who had never worked in a shipyard before, but some, hailing from all over the United States and the world, had never seen a ship, or an ocean, in their lives.

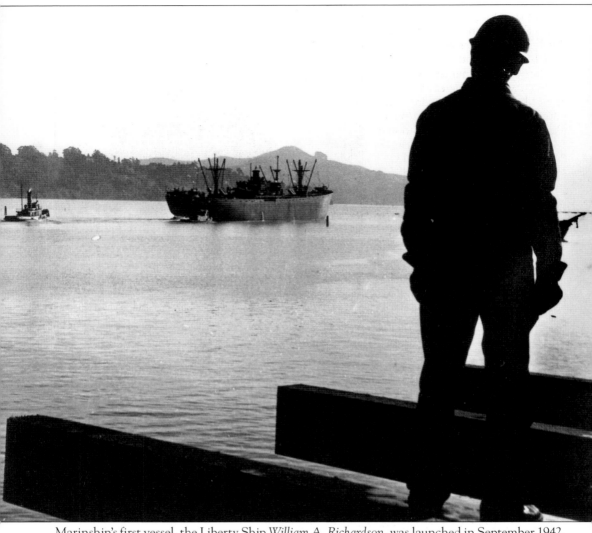

Marinship's first vessel, the Liberty Ship *William A. Richardson*, was launched in September 1942, and sailed from San Francisco on her maiden voyage on November 27, 1942, with 7,600 tons of British lend-lease cargo for Wellington, New Zealand, and Melbourne, Australia. The *Richardson* was a cargo ship, but at times carried American troops across the Atlantic to Africa and Italy, and on two voyages carried enemy POWs to the United States. On one trip, she carried 751 U.S. troops in the cargo holds from France to New York. With the crew, this means that 800 men were crammed into a ship only 447 feet long, with sanitary facilities designed for about 60 men and officers, minimal galley facilities, and no air conditioning. The *Richardson* was retired in 1948, having made eight wartime voyages. Liberty Ships, old, slow, and technologically old-fashioned, were obsolete by the end of the war. Nonetheless, some sailed into the 1960s.

The Liberty Ship *John Muir* slides down the ways on November 22, 1942. The *Muir* was Marinship's fourth vessel. Another ship built at Marinship was named for William Kent, a congressman from Marin County who donated Muir Woods to the U.S. National Park Service to become a National Monument. One wonders what Muir, a famed naturalist, would have thought of leveling a hill and filling in a salt marsh to build a shipyard.

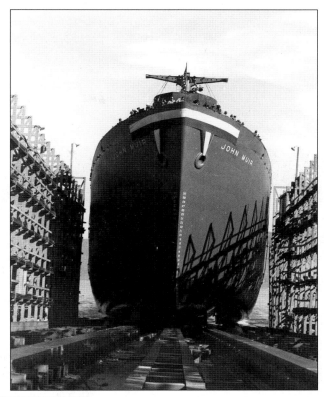

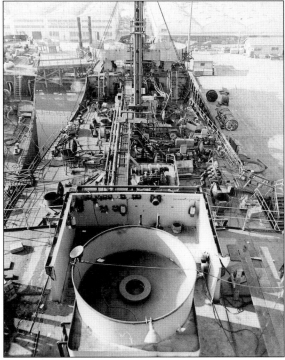

Once a ship was launched, it took many more weeks to fit it out and complete it. Everything had to be seaworthy on delivery, from the steering gear, to the crew bunks, to the tanks and piping designed to hold liquid cargo. This shot shows a tanker (hull 53) 82 days after launching.

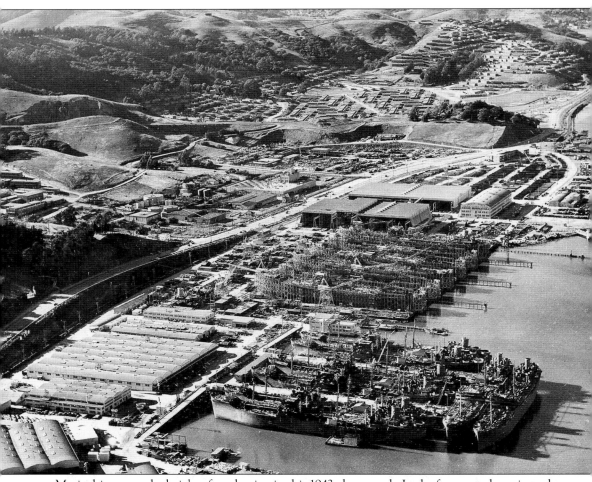

Marinship was at the height of production in this 1943 photograph. In the foreground are six tanker ships in the fitting-out docks. In the middle distance are several other ships on the ways. Marin City worker housing is in the center distance. Across the highway is Mason's Distillery, producer of a brand of bourbon called Good Old Guckenheimer. Destroyed by fire in 1963, today the distillery has been replaced at that site by a condominium development called Whiskey Springs.

William E. Waste, Marinship's general manager, speaks at the launch of the tanker *Mission San Francisco*, Marinship's final vessel. Waste thought there might be a post-war future for Marinship, but after this ship was delivered in October 1945, the yard was shut down.

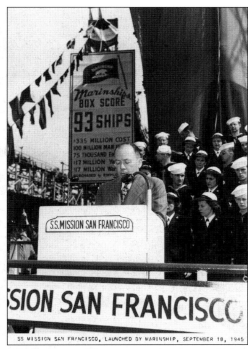

The tanker *Mission San Francisco*, launched on September 18, 1945, was Marinship's last vessel. It was the yard's 93rd ship, and the war she had been built to fight had been over for nearly three weeks. The banners here display evidence of proud accomplishments: 93 ships built, 75,000 total employees, and $17 million worth of war bonds purchased by employees. They also appear to proclaim Marinship "national tanker champs."

SS MISSION SAN FRANCISCO, LAUNCHED BY MARINSHIP, SEPTEMBER 18, 1945

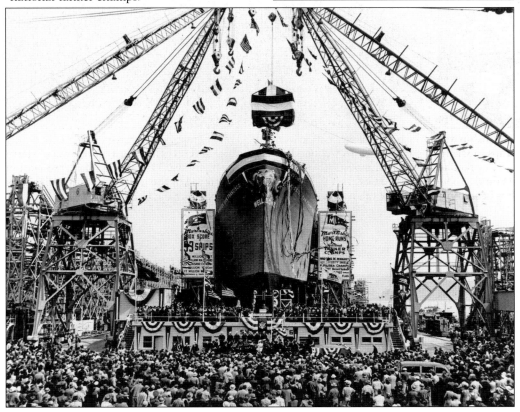

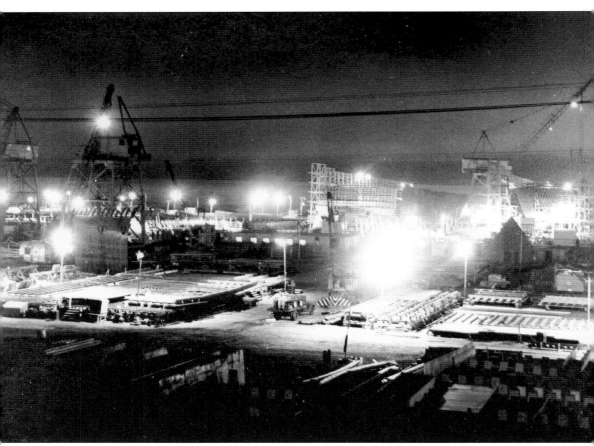

The Marinship ran day and night, seven days a week. It was nationally recognized as having built a tanker in 33 days, a record, and "at the world's lowest cost." At night, the welding torches, sending off flickering blue light, looked surreal—as if a small city had suddenly appeared on the northern Sausalito waterfront. But it did not last long. Three years after work on the first ship started, Marinship vanished like a mirage. Some say, like Brigadoon.

Seven

HABITAT HOUSEBOAT

BY LARRY CLINTON AND PHIL FRANK

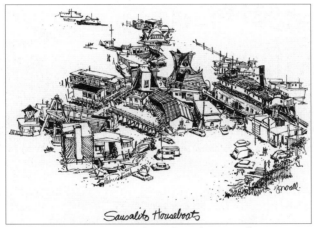

Sausalito Houseboats by John Norall.

Guidebooks sometimes call Sausalito's houseboat harbors Little Hong Kong. Actually they're far from little, and they're uniquely American. This close-knit community of hundreds of floating homes—some sumptuous, some deliberately funky and outrageous—is unrivaled in size, variety, and design anywhere in the world.

Most people believe that living on the water began in the 1960s, when refugees from San Francisco's Haight-Ashbury moved into the abandoned ferryboats and aging barges along the Sausalito shoreline. But, in fact, they were preceded by more than a century of water-dwellers on San Francisco Bay. The bay and its delta tributaries were once San Francisco's market basket, where fish and fowl were harvested for the city's burgeoning population. Oysters, clams, shrimp, and fish were gathered, as well as ducks and geese. Few roads penetrated the wetlands then, and there were few places for market hunters and fishermen to stay overnight.

Responding to that need, floating cabins were built around the bay as early as the 1860s, many in Sausalito boatyards. These craft were designed like ships' cabins. They had only the most basic amenities—bunks, wood-burning stoves, and water barrels. Each had an arched roof, a narrow walkway around the exterior, and a flat-bottom scow hull. They were called "arks." Towed to remote locations and anchored, they would settle on the mudflats at low tide and, when the tide returned, lift off like Noah's Ark.

Some time in the early 1880s, well-heeled Victorians seeking a touch of the bohemian life had large, elegant arks built as summer homes and places for weekend parties. Around 400 of these craft once bobbed on San Francisco Bay. Belvedere, across Richardson's Bay from Sausalito, and the haunt of many wealthy San Franciscans, had as many as 30 arks afloat in its cove between May and September of each year.

Elaborate parties, lit by Chinese lanterns and accompanied by music softly wafting across the water, were frequent weekend events. Guests arrived by rowboat. Grocers and butchers took orders and returned by skiff with the needed goods.

After the 1906 earthquake and fire, most arks on San Francisco Bay became housing for those who had lost their homes. The bloom was off the idea of summering on the water. And fewer and fewer arks left the shelter of the shoreline for deep water.

Possibly a hundred of these forerunners of today's houseboats still exist. Most have been enlarged and placed on pilings along the bay's shoreline. Some have been dragged up hillsides and incorporated into land-based dwellings. A few, however, still float, tugging at their lines and nudging their Johnny-come-lately neighbors, reminding them that they were the first kids on the block.

The first of these more modern houseboats were veterans of World War II, when shipbuilding activity on Sausalito's northern waterfront left behind retired vessels, run ashore and abandoned. Other vessels—old landing craft, lifeboats, pile drivers—were dragged up, relieved of their engines, and left to become part of the scenery. Laborers, veterans caught in a housing crunch, and others moved in. Artists and those seeking an alternative lifestyle soon followed.

During the 1970s, a passionate waterborne community fought Marin County officials for the right to maintain its unregulated lifestyle. But following a series of fierce "houseboat wars," the regulators prevailed, and new piers and shore-side utilities appeared. Soon other kinds of folks were attracted to the new, legal marinas. Newly built, non-navigable houseboats appeared and became legally known as "floating homes." This led to an overall gentrification of the area. Nearly 400 floating homes are now situated on 11 docks. The houseboat harbors have become solidly middle class, with only an occasional vestige of the old bohemian enclave surviving.

But the independent spirit of houseboating survives, along with a strong sense of community among the residents on the docks, all of whom share the unique joys and challenges of living on the water.

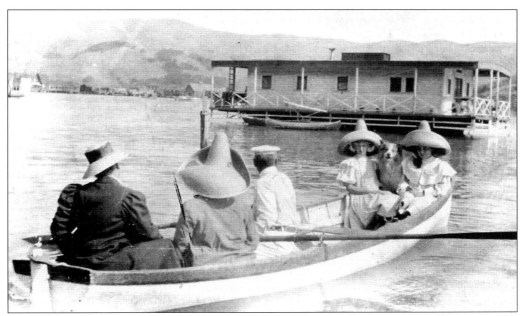

Most early houseboats, called arks, had a common design—wide eaves over walkways on the sides, porches fore and aft, an entry door or French doors on the front, with windows on either side, and an arched roof. Each had steel rings on the hull or deck to allow the ark to be towed and anchored.

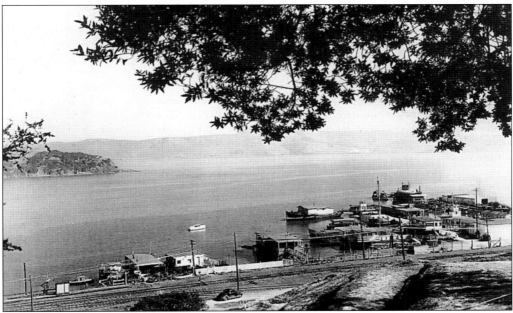

This late-1930s photograph shows the fledgling houseboat community at Waldo Point in the years just preceding World War II. This area consisted of tidal flat parcels owned by Camillo Arques of the Crichton-Arques Boatyard and enlarged by his son Donlon. Many of the structures in this photograph were 1890s arks set on pilings, mixed with working craft and a few structures built on boat hulls.

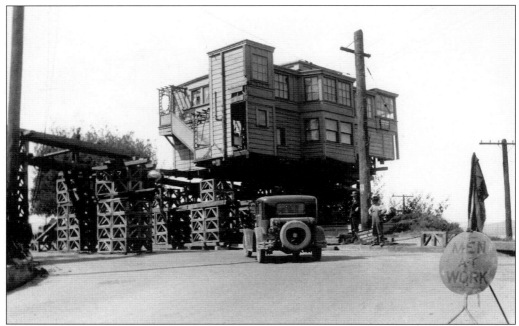

As work progressed on the Golden Gate Bridge, Water Street was widened and renamed Bridgeway to accommodate more traffic. To accomplish this, houses had to be moved. Shown in this photograph is an ark, an 1890s houseboat named *Weona*, that the Akers family built additions to on every side, enlarging it significantly. The *Weona* was moved to the hillside above the intersection of Napa and Caledonia Streets, where it remains today.

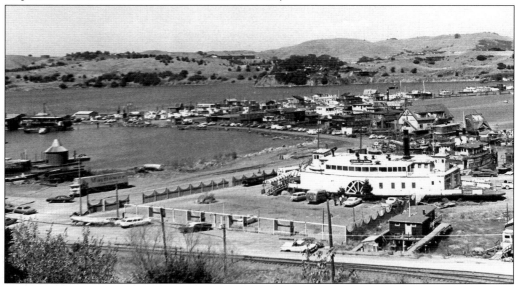

The beached ferryboat *Charles van Damme* was the center of the Gate 6 hippie houseboat community in the 1960s. A sometime restaurant, dance hall, and community center, it was a favored venue for a legendary local rock group called the Redlegs. Behind it in this photograph is the old Spreckels boathouse, which was moved in 1959 to Gate 6 from Shelter Cove in Old Town. The *Charles van Damme* was finally condemned and bulldozed in the 1980s.

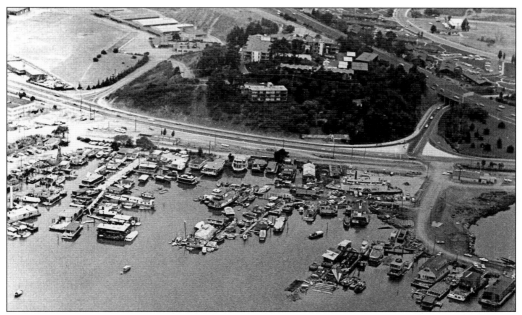

Disorganized and impromptu describes the look of the Sausalito houseboat community in the 1960s, before the present marinas were built. It was a hodgepodge of floating docks, jumbled electrical wiring, and precious little plumbing. But it attracted free thinkers, such as Zen philosopher Alan Watts, sybaritic artist Jean Varda, writer Shel Silverstein, and other off-beat luminaries. Today the houseboat community, like most former bohemian enclaves, has been gentrified. However, a few vestiges of its legendary lifestyle remain.

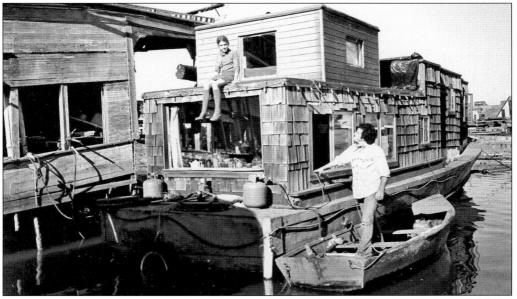

This photograph was taken in the late 1970s, and was the introductory image for a children's book entitled *Suebee Lives on a Houseboat* by Phil and Susan Frank. Suebee and her father, Eddie, are pictured with their boat the *Spicebox*, a converted military craft tied up to the sway-backed ferryboat *Issaquah*. (Photograph by Bruce Forrester.)

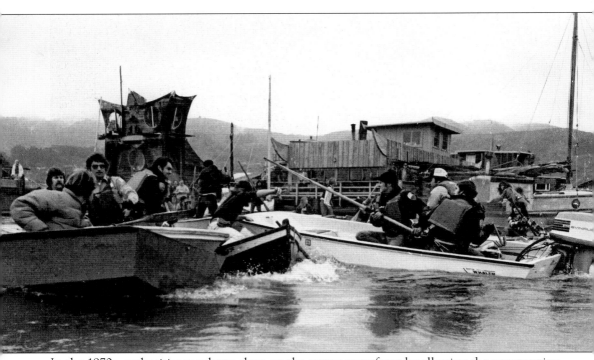

In the 1970s, authorities sought to clean up the ragtag waterfront by allowing the construction of modern marinas, where houseboats could not only be permanently moored, but hooked up to shore-side utilities (especially plumbing) and made to conform to Marin County's building code. Many houseboaters accepted this opportunity to become legal, but others did not. The latter were served with notices to vacate illegally constructed housing, which they ignored. The county sent in enforcers from the sheriff's department to tow the nonconforming structures away. This led to the infamous "houseboat wars" of the mid-1970s, with boat-to-boat jousting matches between hippies trying to keep their houseboats, and sheriff's deputies attempting to remove them from the bay. After incidents like these were broadcast on the local news, the county backed off. Eventually codes were created to address health and safety issues, and a limited number of houseboats were allowed to remain at Gate 5. This photograph is from the second "war," when houseboat owners at Waldo Point Harbor feared that the new expansion would eliminate their homes. (Courtesy Jane Koestel.)

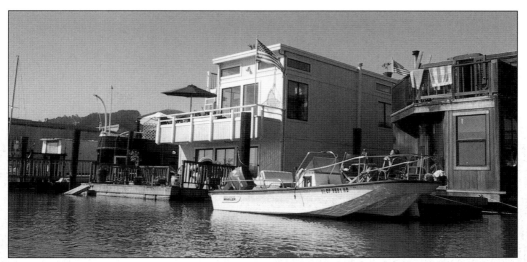

Most floating homes rest on concrete barges that weigh several tons. Yet the homes float when the tide is in because the barges are less dense than the water, and therefore are buoyed up by a force equal to the weight of the water they displace (Archimedes's principle). Floating home docks have full utility hookups. Everyone is equipped with a holding tank connected to the dock. Nothing is allowed to go over the side into the water. (Photograph by Elaine West.)

The SS *Maggie* was built as a steam schooner in 1889. After plying the San Francisco Bay and coastal waters for many years carrying light cargo, she was retired in the 1930s and converted to a home. In 1995, an ambitious restoration of the *Maggie* began. To stop leaks, the old, rotting hull was sawed off and replaced by a concrete barge. In the engine room and bow, now converted to elegant bedrooms, the original hull, built with old-growth fir over oak ribs, is still visible.

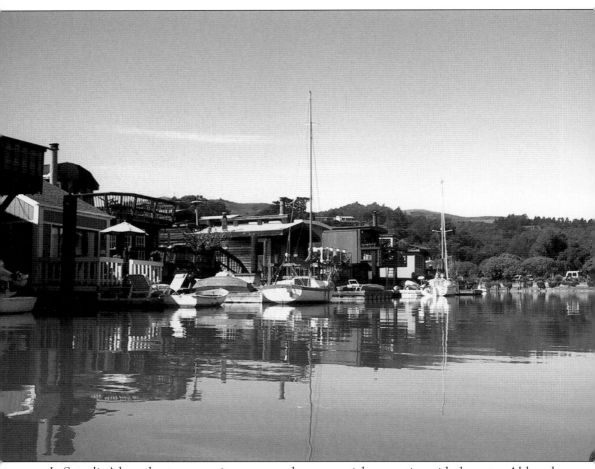

In Sausalito's houseboat community, everyone shares a special connection with the water. Although the homes on each pier are close to each other—as close as eight feet in some cases—their owners do not feel crowded. Their attention is focused on the water, not on the neighbors. People respect each other's solitude, but are always available should an emergency arise. (Photograph by Ric Miller.)

The *Pirate*, built in 1910, was a steam-powered tug that plied the Sacramento River Delta and San Francisco Bay for many years. In the 1930s, it was converted to gas to become San Francisco Bay's first gas-powered tug. The original hull now contains a captain's bedroom, full bath, and a sauna. The *Pirate* has a notorious past as a party boat and has been the home of several local celebrities, including world-famous screen actor and, in later life, Sausalito character, Sterling Hayden. (Photograph by Larry Clinton.)

This architectural masterpiece is one of the most photographed floating homes on the Sausalito waterfront. Called *Train Wreck*, it was built from an 1889 Pullman car of the Northwestern Pacific Railway that was cut in half and integrated into the overall structure. The main floor features the Pullman car dining room with its original mahogany paneling and brass fixtures. (Courtesy Larry Clinton.)

Birdwatching is a favorite activity on the floating homes piers. Seagulls, egrets, herons, cormorants, and terns ply the waters of Richardson's Bay year round, while various species of ducks, pelicans,

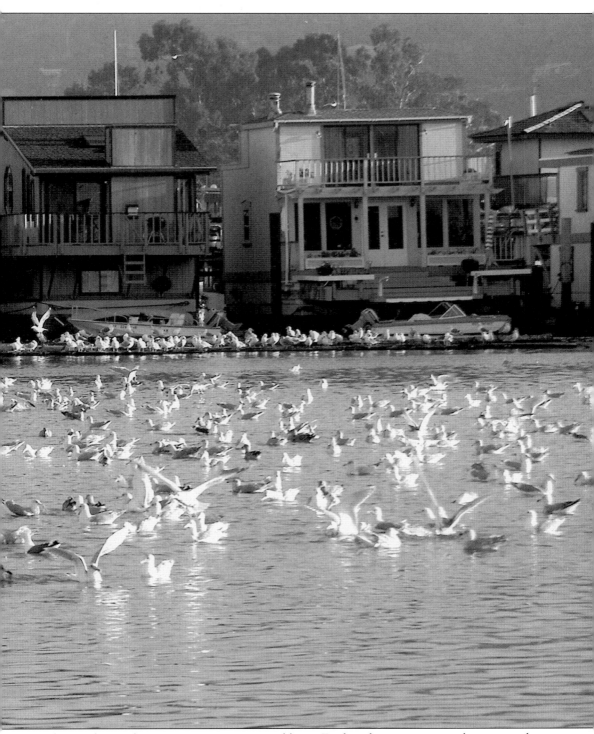

grebes, and Canadian geese visit on a seasonal basis. Feeding frenzies occur in the winter when herring come into the bay to spawn. (Photograph by Emily Riddell.)

Built in 1980, the *Dragon Boat* is four stories of breathtaking elegance. It is entered through an exquisite etched-glass door, and the main level features 20-foot ceilings. A high mezzanine overhangs the modern kitchen with its marble countertops. On the upper level, the master bedroom suite includes a marble fireplace and white marble bathroom with brass dolphin fixtures and etched mermaid glass. At 2,000-square-feet, the *Dragon Boat* is one of the largest and tallest homes in the floating homes community. (Courtesy Margaret Badger.)

Eight

QUIRKY, CONTRARIAN, CREATIVE

BY PHIL FRANK

One Man by Jim Palmer.

Like the tides that tug at the ships in its harbor, Sausalito has its own gravitational pull on humanity. People are just drawn to the place. Today they come mostly to visit and enjoy the extraordinary setting. To the east, a historic waterfront stretches along two miles of stunning views—Richardson's Bay, Angel Island, the towers and spires of San Francisco shimmering in the distance. To the west, the hills rise up. Where they dip, fog spills into town from the ocean, snaking around houses perched high on the ridge, dissipating as it works its way down the terraced gardens, past the winding steps and pathways, along the narrow, twisting streets to the forest of white ships' masts lining the docks.

Creative people, big thinkers, nonconformists, and just plain eccentrics have always been attracted to this enclave by the bay, probably because it's so different from anyplace else. Artists, writers, poets, and philosophers have made it their home, rubbing elbows with boatbuilders,

bootleggers, film stars, rock stars, ex-madams, visionaries, media types, and entrepreneurs. Dozens have done time in Sausalito.

Curious contrasts, paradoxes, and similarities have abounded. As Jack London was working on *Sea Wolf* in Anna Duffy's Old Town rooming house, William Randolph Hearst was underwriting the brass band of the Native Sons of the Golden West. But he was also enraging the citizenry by keeping his mistress on a houseboat on the bay, conveniently anchored below his cliffside mansion.

While former San Francisco madam Sally Stanford was sitting in her signature barber chair, throwing orders at her Valhalla restaurant staff, her parrot squawking on her shoulder, movie star Sterling Hayden was preparing his schooner, *Wanderer*, for a globe-encircling dash from the American court system.

The 1950s Beat Generation, famously associated with San Francisco's North Beach, considered Sausalito its country hideaway, its summer retreat. The art colony and the burgeoning houseboat scene were meant for each other, and together they acted as a magnet for the creative.

As soul singer Otis Redding was penning "Sittin' on the Dock of the Bay," a stone's throw away, Zen philosopher Alan Watts was contemplating the outer edges of the human psyche on his 1880s ferryboat. At the same time, at the other end of the boat, artist Jean Varda was creating a collage of nubile dancers cavorting in a mythical golden city.

Was it the beauty of the natural setting, the mix of hills and water, the cheap post-World War II housing, the abandoned ferryboats, the lumber schooners, the ancient arks? Was it the fishboats, the impromptu gallery openings, the herring runs, the foghorns? Maybe it was the town's long history of scandalous goings on, its edginess, its party attitude? Or possibly its theater companies, its jazz, its originally homegrown and later world-renowned art festival, its highly respected literary magazine, *Contact*? Perhaps it was all these things, and others that can't be put into words, that drew the famous and the infamous.

Sausalito has always taken pride in its characters. Most won't make it into the history books. They were, and are, just part of the landscape, adding something to the Sausalito experience. Frank Anderson was a burly, grey-bearded giant of a guy who ran a nursery business of sorts in New Town, sold wet firewood to the locals, and for a month every Christmas dressed as a scruffy, cigar-smoking Santa Claus.

Frank fought Southern Pacific Railroad for the right to stay on the land he rented, and when the citizenry tried to purchase the property with a bond issue that would guarantee him some future, he fought that too. As a result it didn't pass, and Frank was evicted. So he left, and the town became a little less interesting when he did. Characters are hard to come by these days in Sausalito. But it still has a few and, in the spirit of its quirky, contrarian past, it takes great pride in those few.

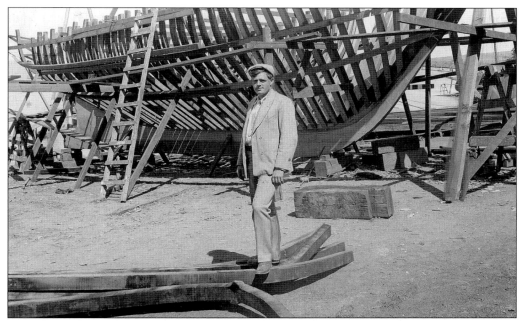

Jack London, one of the country's most successful writers in the early 1900s, loved gritty waterfronts, boatyards, and saloons—and Sausalito had them all. London gravitated to Old Town in the late 1890s and rented a room in Anna Duffy's rooming house, which was above a saloon. Today it is called the Jack London House. Pictured here at a San Francisco boatyard, London stands by the ribs of the *Snark*, immortalized in his famous book *The Cruise of the Snark*.

William Randolph Hearst, future newspaper magnate and builder of Hearst Castle at San Simeon, spent several years just after college in Sausalito at Sea Point, a mansion on the hill above Old Town. Hearst contributed generously to civic causes and activities, but when he brought his mistress, Tessie Powers, to town and ensconced her in an ark off Old Town, he was publicly rebuked. Hearst was unfazed by the controversy. However, a few years later, when local officials balked at his plans for a new mansion and private bridge down to the waterfront, Hearst packed up and left town.

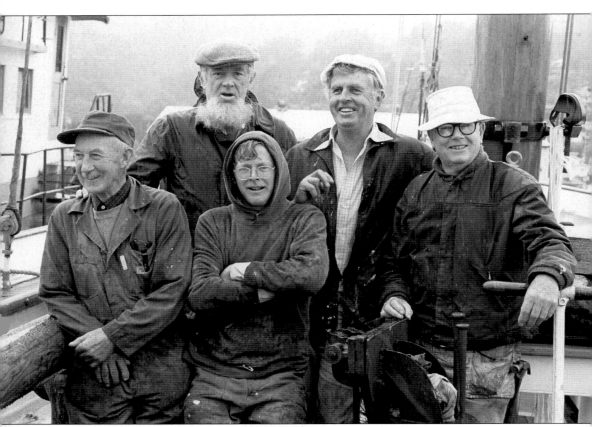

Sterling Hayden lived life big and loved the sea, but he hated modern society and the acting career that made him famous. Among his enduring roles were classic portrayals in *The Asphalt Jungle*, *Doctor Strangelove*, *The Long Goodbye*, and *The Godfather*. His publicist said it best: "Sterling Hayden was born in the wrong century. He should have been a sea captain in the 1800s!" Hayden came to Sausalito because this was where boats were. It was here that he moored his beautiful, 99-foot schooner, *Wanderer*. Following a divorce decree that ordered him not to sail to Tahiti with his children, he promptly set sail for Tahiti and took the children with him, making headlines everywhere. By the time he returned to Sausalito, Hayden had developed the look of a wild-haired, bearded Moses, carrying a large walking staff and wearing sandals and a robe. Visitors were agog. Locals were always delighted to see him. Hayden died in Sausalito in 1986. Pictured here, from top left, are Hayden, Harold Sommers, John Linderman, Alex Davidson, and Kit Africa.

The character people most closely associate with Sausalito is Sally Stanford (also known as Marsha Owen and, early in life, as Mabel Busby), pictured here in the company of a young Marlon Brando. Sally came to Sausalito after a raucous career in San Francisco as proprietor of a high-class bordello. When she arrived in the late 1940s, she left her former life behind and, in her own words, "went square." She purchased the boarded-up former German *biergarten*, the Walhalla, in Old Town, changed its name to Valhalla, and opened it as a restaurant with all the trappings of a bordello—stained-glass lamps, swag curtains, plush carpets, and live piano music. Sally held forth nightly, ensconced next to the bar where she could check the receipts, often with her parrot on her shoulder. She ran for city council several times as Marsha Owen, but was finally elected by a wide margin on her sixth try when she ran as Sally Stanford. She became mayor in 1976, but often said she preferred her previous status, when she held the title of vice mayor. Sally helped out with uniforms for Little League, took an active part in civic affairs, and was a presence everyone missed when she died in 1982.

Juanita Musson of Juanita's Galley, a little Gate 5 Road eatery on the northern waterfront, frankly called her place a "dive." The Galley opened at 5:00 a.m. and catered to fishermen. Animals, including a rescued fawn, wandered around the place. If upset with a cantankerous customer, Juanita was just as likely to throw a rolling pin or a skillet at him as serve him. She operated her Galley in three locations in Sausalito, the last one being the grounded ferryboat *Charles van Damme*, before moving her eccentric establishment to Sonoma County.

Expectations for service were defined by Juanita's "House Rules." There was no complaining about the quality of the food. Juanita's classic line was, "Eat it or wear it." It's a known fact that a local police officer, tired of waiting for his hamburger, left the Galley without paying. Juanita followed him and threw his hamburger through his squad car window. Juanita no longer lives in Sausalito, but for all the years she graced the waterfront, she gave it special color.

Juanita's
GALLEY
GATE 5 ROAD · MARINSHIP · SAUSALITO, CALIFORNIA

HOUSE RULES

1. Pour your own coffee.
2. Write your own order. Be sure to put your name on order so we can find you.
3. Our food guaranteed — but not the disposition of the cook.

NAME: Hall

ORDER:

1386

ORDER TIME

CHECK HERE FOR SPECIAL SERVICE ✱

SLOW ☐ **DON'T CARE** ☐
***DAMN* BIG RUSH** ☐

✱ Doesn't mean you will get what you ask for — But check any one that will make you feel better.

Shel Silverstein was internationally known as a writer of poetry for children (*Where the Sidewalk Ends, A Light in the Attic*), a cartoonist for *Playboy* magazine, a composer ("A Boy Named Sue"), and a recording artist. Silverstein's stays in Sausalito were occasional, but when he was in town, he was *really in town*. He loved the houseboat community and considered it a unique place to live. His long-time traveling pal, Larry Moyer, remembers, "We were always looking for good food and bad women." (Photograph by Larry Moyer.)

Soul singer Otis Redding wrote his biggest hit, *Sittin' On the Dock of the Bay,* while sunning himself on a friend's houseboat following a gig at the Monterey Pop Festival. The singer died at the age of 26 in a plane crash, just days after *Sittin' On the Dock of the Bay* was recorded.

At the north end of the Sausalito waterfront, aboard the 1880s ferryboat *Vallejo*, lived two of Sausalito's more notable characters. One resided on the west end of the boat, the other on the east end. Alan Watts was an author of international renown who held fellowships from Harvard and was widely recognized for his Zen writings and public lectures. He wrote more than 25 books on Eastern philosophy, Buddhism, and the need for Eastern wisdom in modern life. His side of the ferryboat was sparsely furnished and lacked color and visual stimuli—strictly a place for meditation.

On the other side of the *Vallejo* lived Jean Varda, a Greek collage artist who was the yang to Watts's yin. Varda's side of the boat was a riot of color, sculptures, paintings, food, wine, music, animals, and people. Varda lived for celebration. He was known internationally for his art, which he created from dresses and clothing purchased from the Sausalito Salvage Shop. One would imagine that Varda must have driven Watts crazy, but they were the best of friends. Varda died in 1971, Watts in 1973. The *Vallejo* is still on the waterfront, preserved as a memorial to two great philosophies of life.